Wales
Land of My Father

Wales
Land of My Father

PHOTOGRAPHS BY
DAVID HURN

Introduction by Patrick Hannan

Thames & Hudson

With thanks to my brothers Bill and Josef and sister Sue, and to Keith,
who all continuously spark my enthusiasm

PUBLISHED TO CELEBRATE THE MILLENNIUM EXHIBITION
ORGANIZED BY THE NATIONAL MUSEUMS & GALLERIES OF WALES
Mamwlad Fy Nhad/Land of My Father

The National Museum of Wales has acquired for its permanent collection copies of the
following photographs shown in this book:
Plates 2, 3, 6, 7, 10, 11, 14, 16, 21, 24, 37, 38, 39, 40, 45, 48, 52, 53, 57, 61, 62.

First published in the United Kingdom in 2000 by
Thames & Hudson Ltd, 181A High Holborn,
London WC1V 7QX

British Library Cataloguing-in-Publication Data
A catalogue record for this book is available from
the British Library

ISBN 0-500-01983-5

Printed and bound in Singapore by C S Graphics

Contents

Introduction

In the summer of 1994 I was asked by the Wales Tourist Board to go to Seattle to carry some bad news to the people who would be gathering there for a weekend celebration. I was advised to be tactful but firm, cautious but unambiguous: Wales, my message was, had disappeared. Not physically, of course, although there was more than an element of that in my story, but Wales as it was understood by many of the people who had made their way to the event from all over North America.

The occasion was the Welsh National *Gymanfa Ganu*, a hymn-singing festival which is staged every year somewhere in the United States. It's the culmination of three days of unashamed nostalgia during which people reassure themselves and each other about a shared inheritance, even if the separation of time and distance often brings a deeply romantic quality to the description of what that inheritance might be. Indeed, in most of Wales these days the *gymanfa ganu*, once regularly put on by hundreds of chapels where the language of worship was Welsh, is pretty much an anachronism, but in North America it perhaps represents the idea of a distinctive country rather than the country itself. It is a reassuring touchstone of continuity, if an illusory one.

I was sent to drop a pebble of realism into this pond of memory. Many of those who went to Seattle were elderly, frequently two or three or more generations away from Wales; well-to-do American matrons, men in plaid trousers. Significant numbers had never been to Wales at all. The younger people present were often rummaging around in some kind of ancestral attic looking for, as one said, *ethnicity*, a commodity increasingly valued in a global culture.

The image many of them carried was erratically familiar: of a nation of Welsh-speaking, chapel-going, hymn-singing, rugby-playing, coal-mining, ironmaking, slate-cutting, sheep-farming, look-you troglodytes peering truculently through a permanent light drizzle. And who could blame them since this is a view still held by large numbers of people in England who have no real excuse for not knowing better?

But then, most people in the world don't get even that far. To mention Wales is in general to provoke glazed bafflement or perhaps some kind of guessing game ('Ain't it a city in Ireland?'). To say that, no, you're not English but Welsh is, in France, to be met with a shrug of Gallic dismissal. ('*Mais, c'est la même chose.*') In Seattle I asked, as journalists do, a taxi driver. He thought for a while and eventually dragged something from the back of his mind. 'Gee, yeah. I've heard of the Duke of Wales.' And this at a time when the late Princess Diana and her estranged husband were probably the most famous couple in the entire world. What most of us have in common, it often turns out, is our anonymity.

I'd been to the *gymanfa* once before. In 1975 I'd travelled out in a party which had included the Secretary of State for Wales, some civil servants, assorted industrialists, a bishop and a male-voice choir. So quintessentially Welsh was this outing that, as our Boeing 707 carried us westwards, high above the Atlantic, we had a whip-round for the driver. Later some of us were to demonstrate our effortless capacity for national stereotype by being thrown out of what we were assured had been Dylan Thomas's favourite New York bar.

In 1975, though, the fondly treasured clichés still represented a recognizable, if eroded, version of reality. By 1994 they had turned into archaeology. In those nineteen years, indeed, Wales and its past had been abruptly separated and it was now often necessary to hunt for clues as to what it had once been, the shards from which you could piece together a picture of a lost civilization. That was essentially the message I was carrying to Seattle, although, frankly, it was one difficult enough to grasp in Wales itself.

In fact the figure of nineteen years is a considerable overestimate. The processes that transformed Wales swept through the country in a single decade. Many of the things that marked out its distinctive character in 1980 had more or less disappeared by 1990. Nowhere more so than in the two industries which had contributed so potently to the identity of Wales: coal and steel.

Now, of course, it's easy enough to say you could see it coming. The coal industry had been in decline for decades, since before the First World War you could argue, certainly since the days in the 1920s when in South Wales alone it employed more than a quarter of a million men. Even as late as 1975 there were well over thirty thousand colliers in Wales – a continuing link with a mighty industrial past. Then again, only a few years earlier, Welsh miners had been in the forefront of the strikes which first, in 1972, humiliated the government over pay and conditions and then, in 1974, drove it from office. For the first time in their history the miners, although severely depleted in numbers, thought they could do anything. For a while, people believed them.

Because the coal industry was so intimately associated with injury, disease and premature death, it was also routinely reviled and resented by those who worked in it. Time after time miners' leaders would be applauded when they said they looked forward to that glorious day when the last miner came up from the last pit. The paradox was in the conflicting desires which wanted to keep collieries open for economic reasons but also to see them closed for social ones. Even so, the industry was so much part of what looked like the immutable fabric of a particular society hardly anyone believed it would actually happen. It did, though, and with a speed that left everyone breathless. By the time I made that trip to Seattle in 1994 there was a single deep mine left in South

Wales, Tower Colliery at Hirwaun in the Cynon Valley. Its defiant and lonely survival was to turn it into a kind of sentimental tourist attraction for many people who not long before had been largely indifferent to the lives of the thousands who worked underground.

That other foundation stone of industrial Wales, steel, in 1975 still employed sixty thousand people in various works around the country. Too many works and too many people, often in the wrong places, according to the increasingly pressing terms of world trade. But, as in coal, people didn't believe their working world and the communities it supported would somehow be dismantled. Governments twiddled their thumbs, hoping for something, anything, to turn up. It didn't, and when another administration eventually bit the bullet in the 1980s, five jobs out of every six in the Welsh steel industry were lost.

The importance of these events is easy enough to appreciate in terms of the people who've been the helpless victims of structural change, but the consequences weren't simply economic. They also altered the nature of society over a large part of Wales. A community built on a single industry – like coal, steel, slate quarrying or textiles – is a kind of organism nourished by the common experience of work. Everyone within that community understands the nature of what's involved. Wives, children, shopkeepers, publicans, teachers and the rest of them are part of the system that governs their lives. They share it with each other but, largely, not with the outside world.

When the work goes, and the common experience with it, it's scarcely surprising that people find themselves disorientated. The long rows of terraced houses which run almost unbroken for twenty miles along the hillsides of the South Wales valleys are there for only one reason: the demands of an industry in what was once the most famous coal-mining area in the world. Now coal is finished, but the people remain and they have to establish a new relationship with a society that is no longer recognizable as the one in which they grew up.

It's a process that reaches into the fabric of a particular way of life. Hard manual labour gives way, when there are new jobs, to the softer practices of the factory floor and the assembly line. More women, fewer men, go to work and the traditional relationship between the sexes is irrevocably changed. So is that between the generations now there is no pit, no furnace, even to warn your son against.

At the same time the landscape itself has reflected industrial upheaval. The tips, the heaps of coal waste which were so much part of the topography we'd even forgotten they were man-made, have mostly been cleared away. Down on the coast in Cardiff's docklands, the loading tips no longer groan and clank night and day over endless

cargoes of coal. Instead, cranes lift prefabricated sections of offices and hotels and penthouse flats as a tide of gentrification sweeps down from the city. But a generation or so ago this was Tiger Bay, hectic, cosmopolitan, tumultuous, vivid and dangerous, in the way the world's great sea ports usually are. Now it's Cardiff Bay and the man sitting next to you in the wine bar is more likely than not to be a television producer.

One of the most persistent themes of modern history has been that of exile, the displacement of people for religious or political or economic reasons. Welsh people are often drawn to this idea, although, unlike the Irish, they have failed to make an industry out of it. They went in some numbers to America and by 1890 there were 100,000 people of Welsh descent recorded as living in the United States. More significantly, though, in the 1920s and 30s almost half a million people left Wales, driven by the appalling poverty inflicted by the Depression to find work in the Midlands and the South East of England. A relatively short journey to the Morris Motors plant in Oxford wasn't perhaps in the same dramatic league as a storm-tossed voyage across the Atlantic to another continent, but it was an enforced absence none the less, and most of those who went never returned.

Sixty or seventy years later, the impact of economic change wasn't quite the same. Instead of being exiled from their country, people have been exiled from their past. Or they believe they have. We live in a museum culture and what we once were is in the process of being tidied away. Except in the old photographs, how can I discover, any young person might now ask, the land of my father?

Well, if you believe history isn't simply a series of dislocated events but is, among other things, a way of understanding your present condition, then the answer is all around. What Wales has become is intimately bound up with what it once was, although the headlong nature of change might have helped conceal that fact. It is something revealed by David Hurn's photographs in which he has for so long patiently captured the nature of Wales and its people.

In the 1970s there was a feeling that Wales could remain pretty much as it had been since the nineteenth century, although that wasn't to say that everything would stay exactly the same. Some heavy industries were declining, naturally, but that didn't mean they wouldn't serve us for a long time yet. Rural depopulation was a persistent problem but, then, it had been for a hundred years. The Welsh language was in continuing decline – the number who spoke it was down to one in five – but there was nothing new about that. For many people the answer to such problems lay in a strong central government able to manage humanely a process of gradual change. The fact that at that stage Britain had a weak central government was not thought particularly relevant.

That was one of the reasons, I suspect, why in 1979 the people of Wales voted with such vehemence against a constitutional change which would have created an elected assembly to control and administer many aspects of

Welsh public life. There were plenty of other reasons for rejecting the deal, not least distaste for the transparent tactics of politicians clinging to office while desperately trying to find some method of dealing with the nationalists, especially those in Scotland, but in Wales too. In a referendum Welsh voters showed exactly what they thought of the idea by a majority of four to one.

Almost nineteen years later, on 18 September 1997, Wales was a different place and the same question got a different answer. 'Wales Says "Yes"' was the headline writers' version of events, but they could have written more accurately, 'Wales Says "Oh, All Right Then"'. The majority in favour of an elected assembly was 6,721 out of a million votes cast. Another million people didn't bother registering their views at all. It was hardly a thunderous endorsement of a radical shift in government, but it was enough.

There are plenty of reasons why substantial numbers of people in Wales should have changed their minds in the intervening period and why others should have been indifferent rather than actively hostile. One was a sense that the way in which Britain was to be governed was altering anyway. The Scots would certainly vote for their own parliament; the regional character of the European Union was becoming increasingly significant; systems of proportional representation were to be introduced for some elections; it looked as though reform of the House of Lords would, hundreds of years after practically everyone else in the world had done so, remove the hereditary principle from the government of the United Kingdom. In these circumstances perhaps it would be foolish to be left behind.

There was another factor. It's impossible to assess how important it was, but people in Wales could then look back over a decade and a half and understand how much of their once familiar world had now become unrecognizable. Economic and social change, not all of it bad, had been visited upon them by an authority that was remote and impersonal. Their influence over the direction of their lives had been minimal. Perhaps acquiring a little more power over their own destinies, even that tiny bit now on offer, might make some difference. In that sense, constitutional change can be seen as a product of the past rather than as a break with it.

In its turn, the new constitutional settlement endorsed by that paper-thin majority in the referendum makes Wales a different kind of place. An elected assembly, however restricted its influence, is a focus for a debate about what sort of place Wales is and what sort of place it should be. It is also, we shouldn't forget, a focus for intrigue and gossip. The voters had hardly had time to make a cup of tea before the first sexual scandals broke within the new dispensation. While that might have been the sort of thing that eventually brought the previous Conservative

Government, and politicians in general, into public disrepute, at least these were *our* sexual scandals. It all comprised an important addition to the constituency of matters of specifically Welsh interest.

Then people say, it's not much of an institution is it? It's just a sewing circle, really, one London journalist suggested – and in a sense he was right. An instrument of government which can neither make laws nor raise a penny of its own revenue risks becoming an object of distracting public argument over what it is as much as over what it does. That will inevitably become part of the conflict as politicians skirmish over the boundaries of power. The Scots have the power to impose a modest income tax, even if, for the time being, they choose not to exercise it. Why not us? people will ask. Why should an *English* Cabinet Minister tell us how to run *Welsh language* television? And for their part English people will continue to inquire, as they often do, since Welsh MPs still sit in the Westminster parliament, why Welsh politicians should influence the way they run their schools or hospitals in England when the English can't do the same for Wales. That referendum, as we can see, didn't resolve the argument, but began it.

To the rest of the world, to the rest of Britain indeed, these are impenetrable arguments about obscure matters, but they represent rather more than a piece of tinkering with the way we choose to arrange our systems of government. They are also part of the idiosyncratic Welsh version of that search for ethnicity being conducted by some of those people at the Seattle *gymanfa ganu*, an increasing need people have to belong somewhere specific. It's a sort of tribalism, perhaps, in response to the bland and unknowable multinational networks of business, communications, entertainment and culture that keep telling us who they think we are.

It can arouse some startling responses. In March 1999, the hugely successful Welsh rock band, Catatonia, staged a concert in Brixton, in South London. At one point their lead singer, Cerys Matthews, sang what is, in a sense, the band's anthem. Three thousand people sang back raucously: 'Every morning when I wake up, I thank the Lord I'm Welsh.'

But this was in Brixton, in South London, and practically everyone in the audience was … English.

PATRICK HANNAN

My father and his forebears were all born and lived in Wales. By a quirk of timing I was born in England. Although quickly reinstated to our South Wales family home, the spectre of 'born in England' has permanently hung over me. The exploration of this dichotomy has been a driving stimulation in trying to understand my culture. I have wanted to discover my place in Wales and explore my contact with my fellow Welsh. If one examines life, then one should follow the argument wherever it leads. My tool is photography and the nature of photography is that, as you work, you continually record a world that has gone for ever yet continuously see the new unfold in front of you. The old and the new are in uninterrupted contrast. My exploration is personal, thus many aspects have been ignored. What is passed over is mainly through lack of time and space. All vision has been inspired by love and, one hopes, directed by intelligence. My own truth is my ultimate criterion. Intensity of attention and the search for beauty are how to find it.

David Hurn

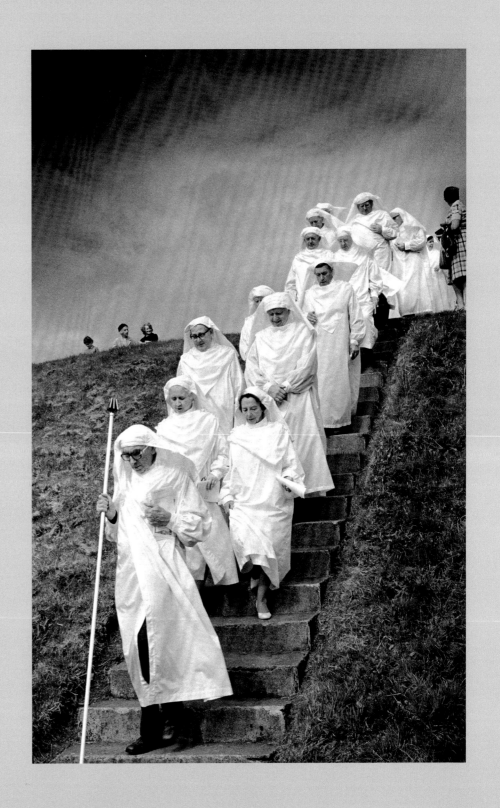

1 Carmarthen

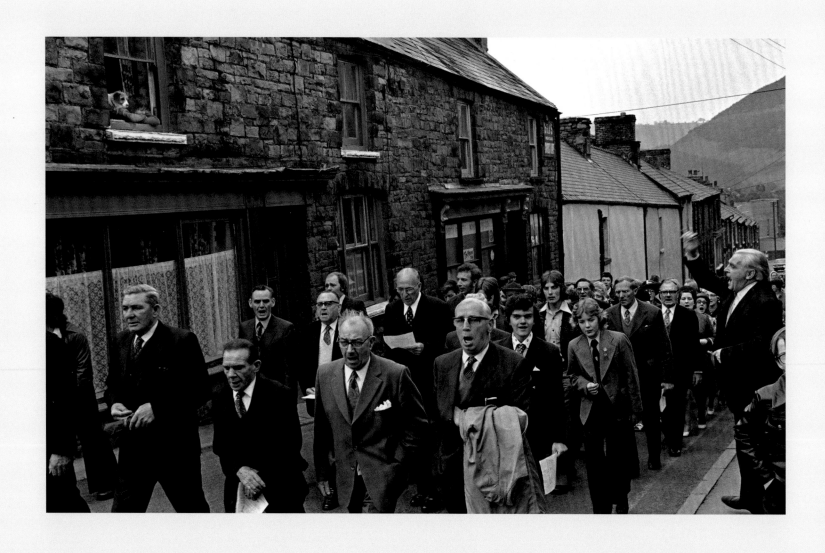

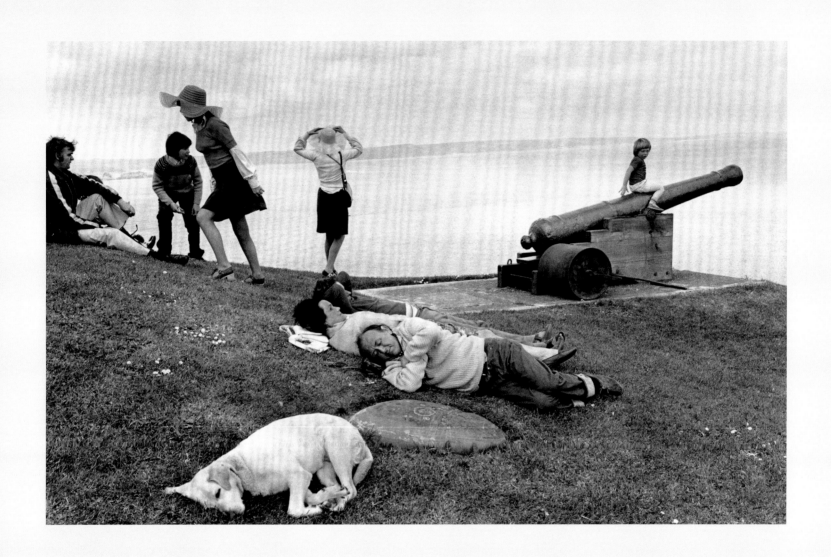

3 Tenby

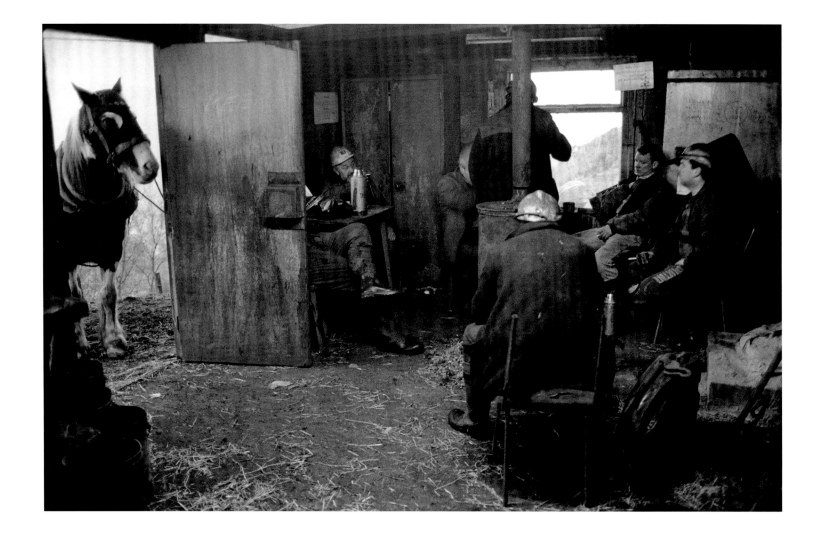

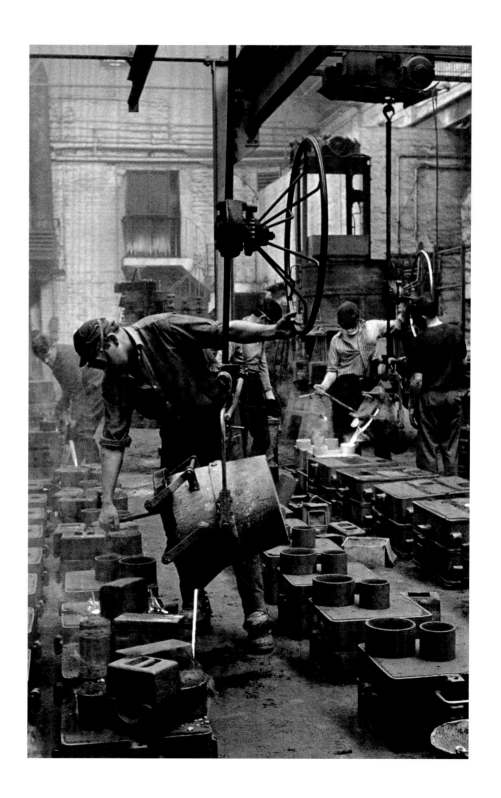

5　Neath

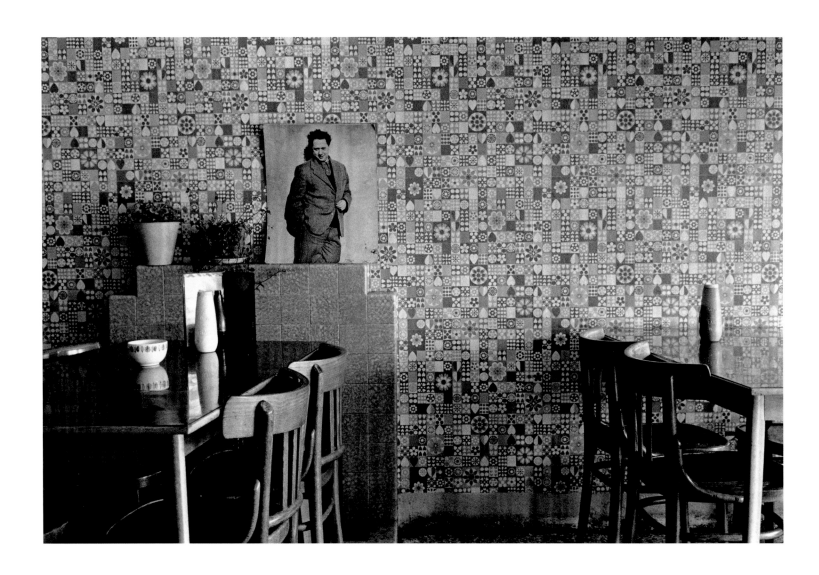

6 Laugharne

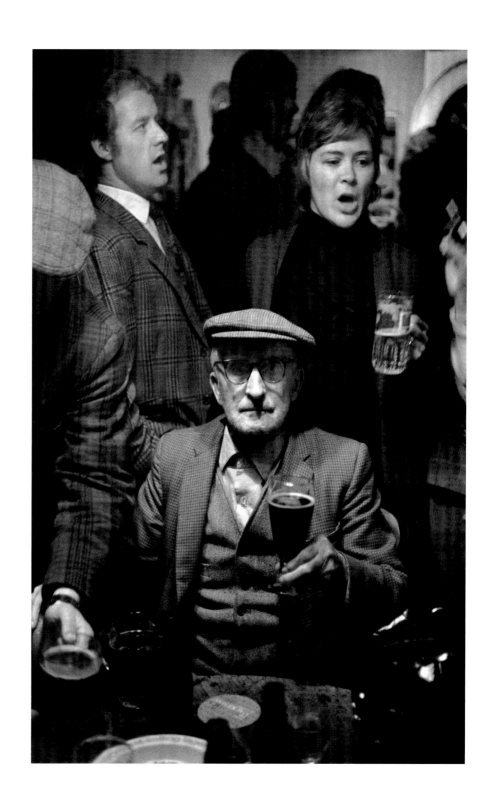

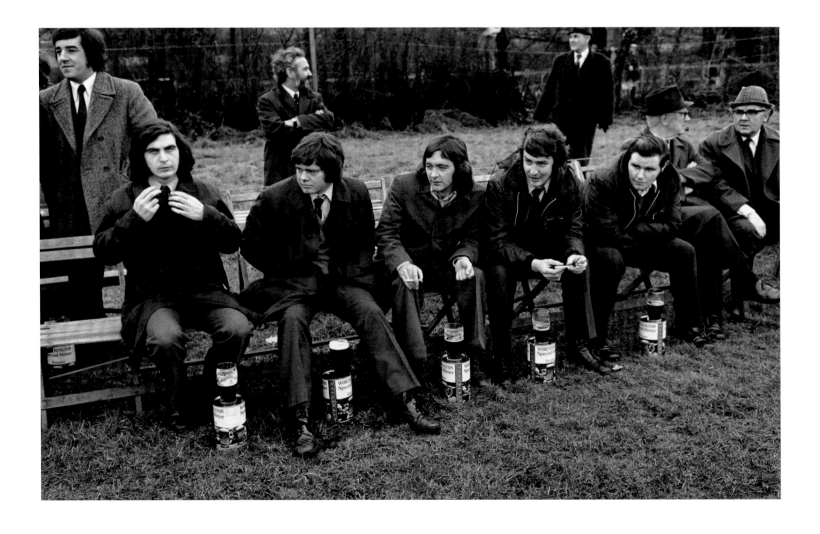

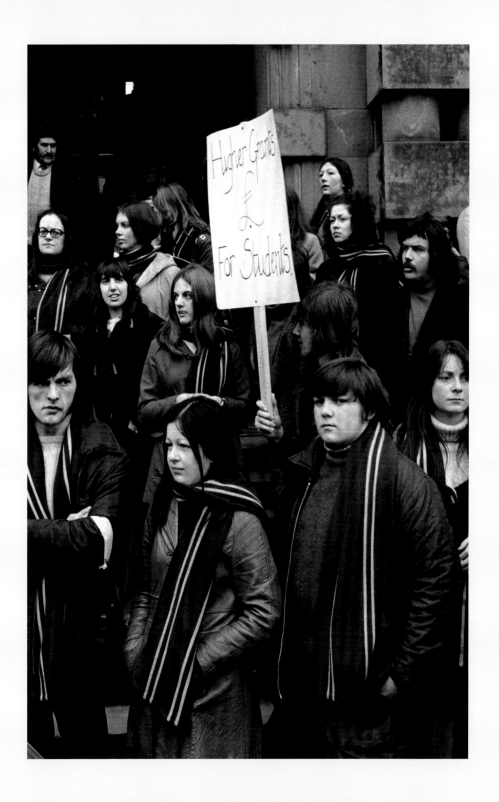

9 Newport

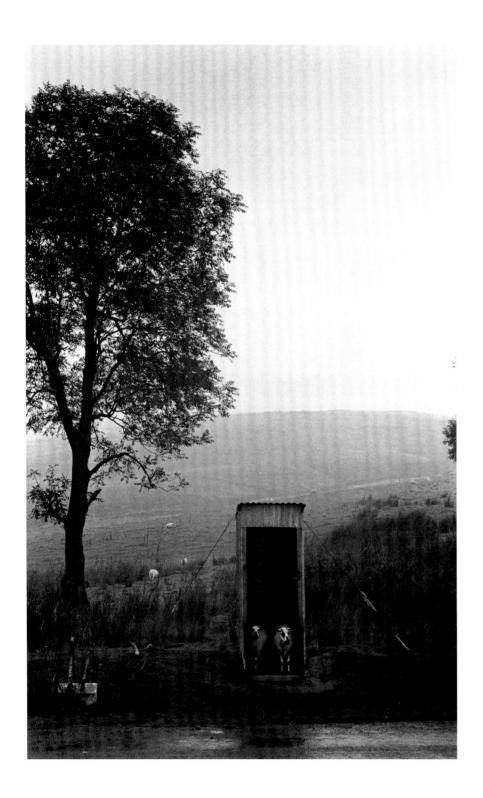

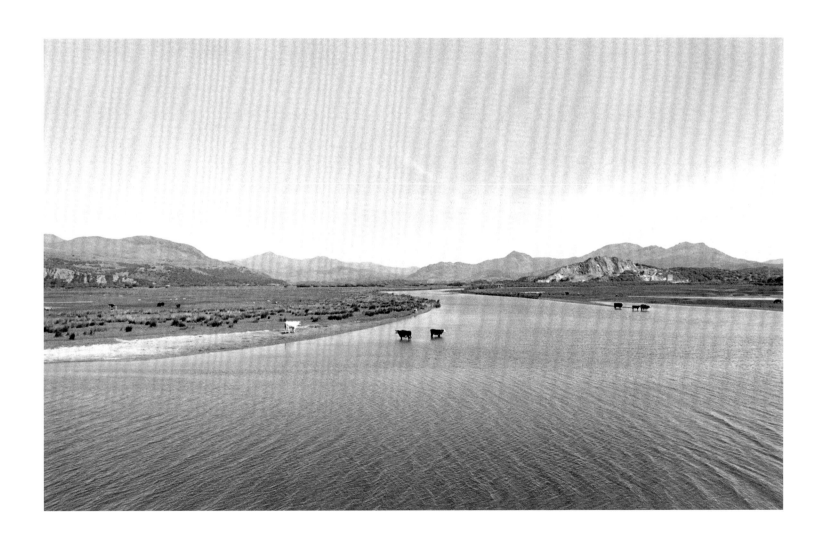

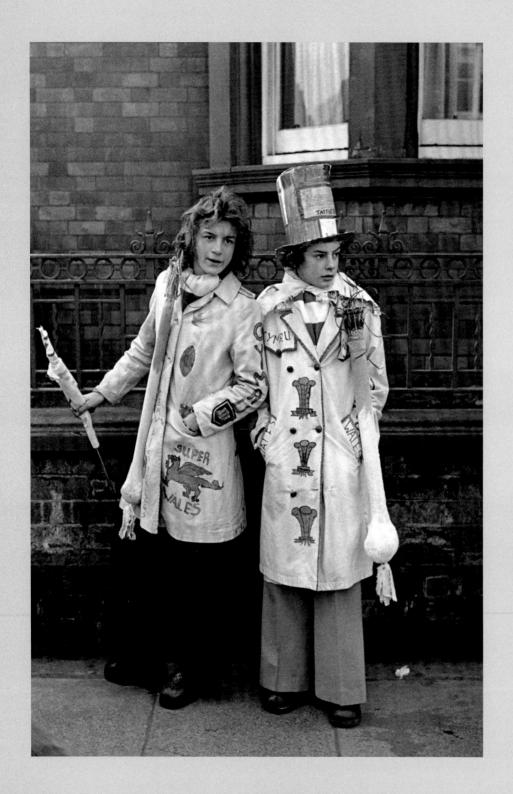

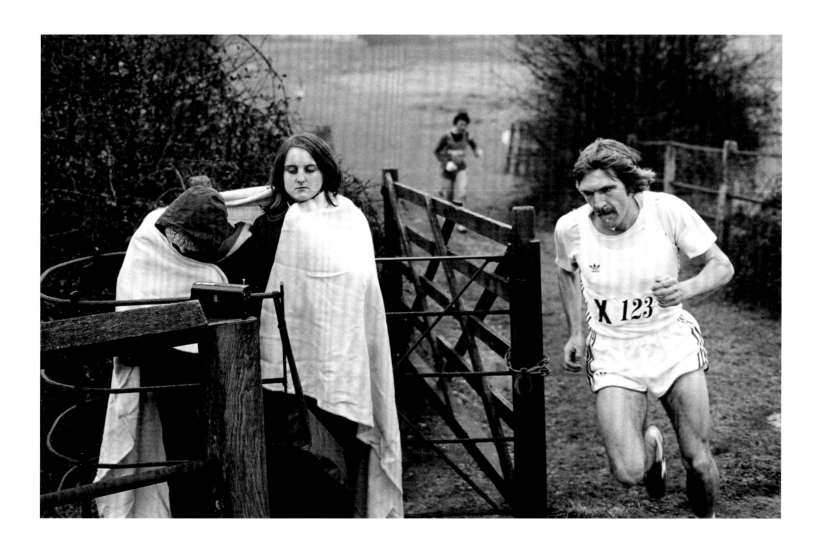

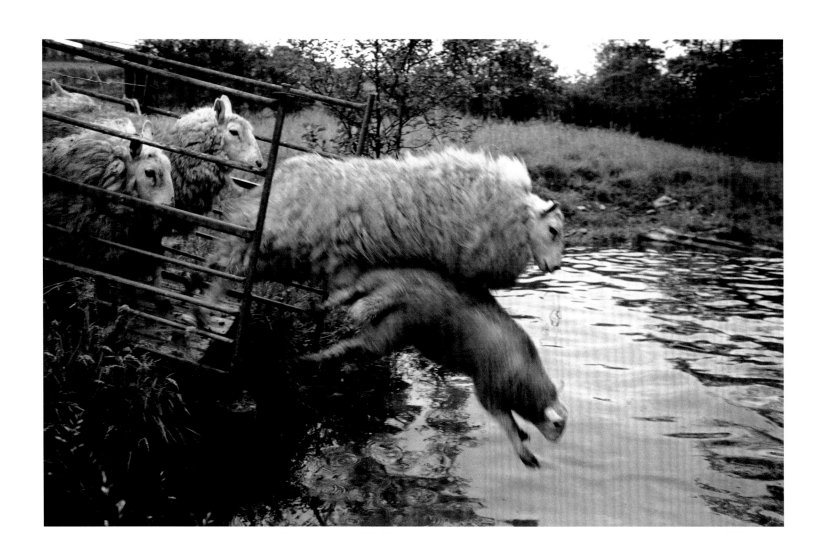

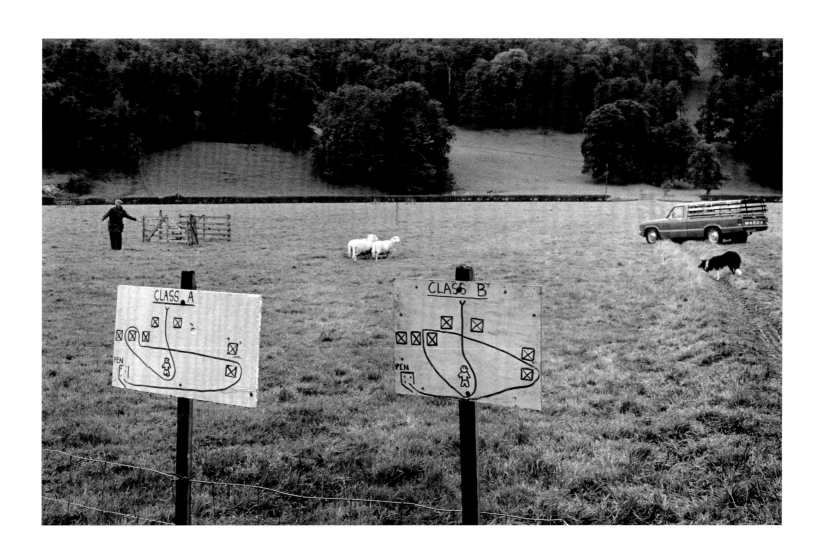

16 Aberavon

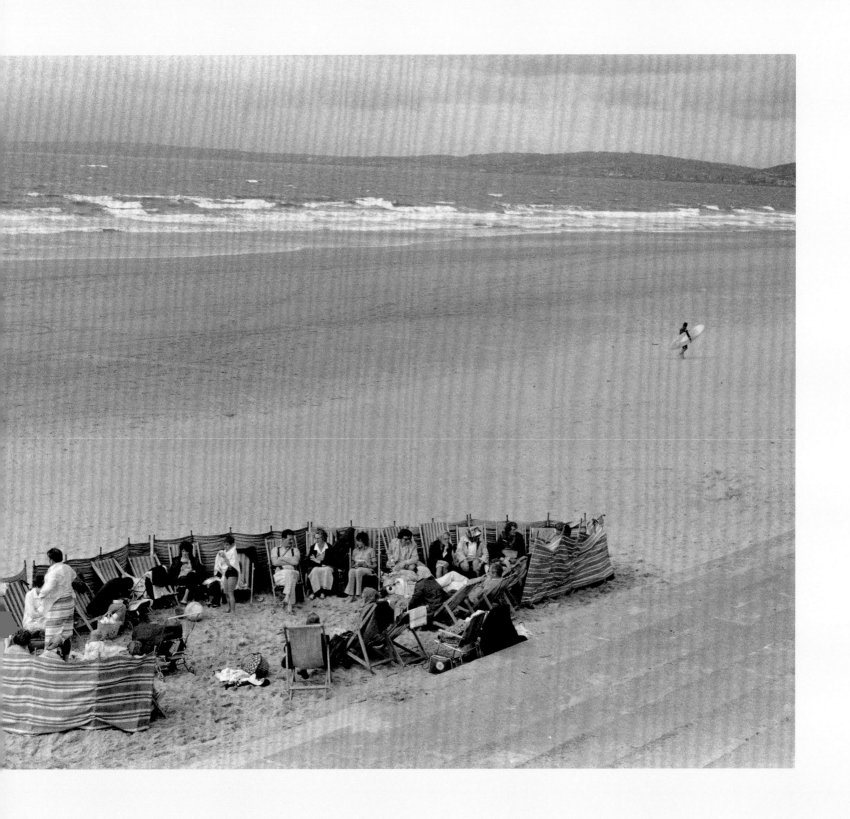

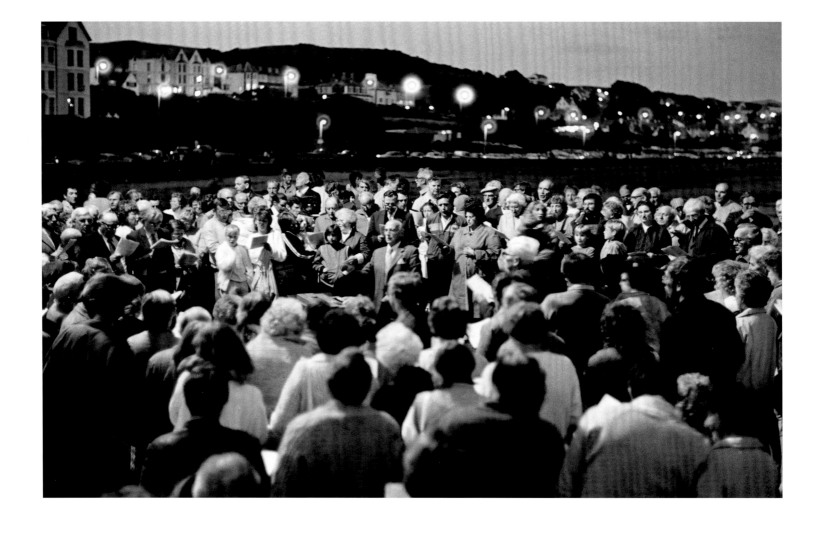

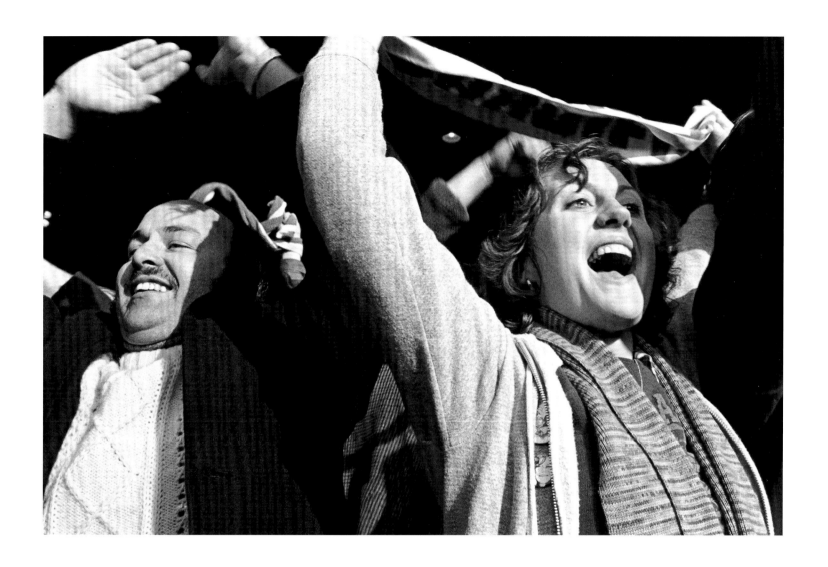

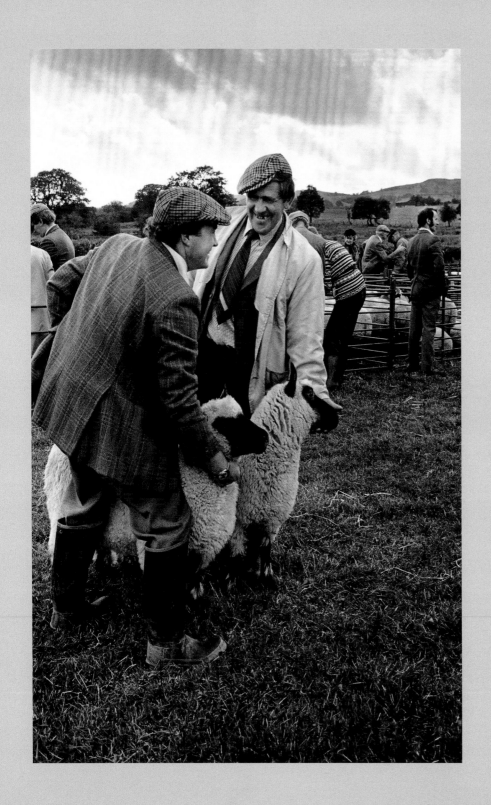

19 Llanafan-fawr

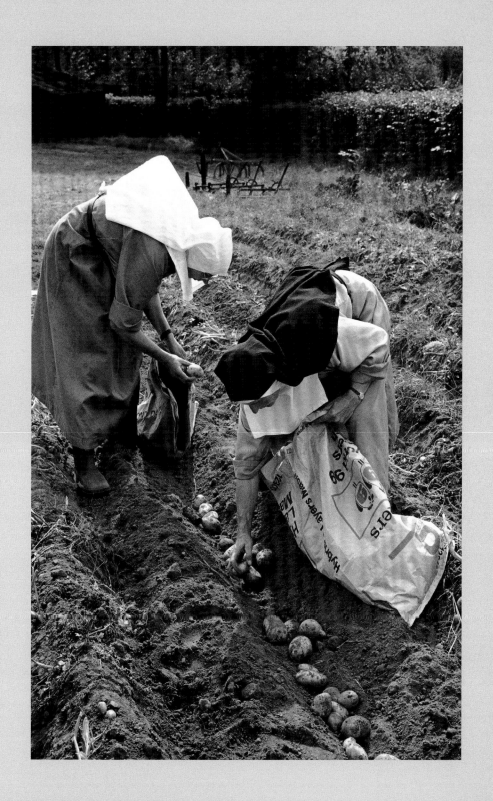

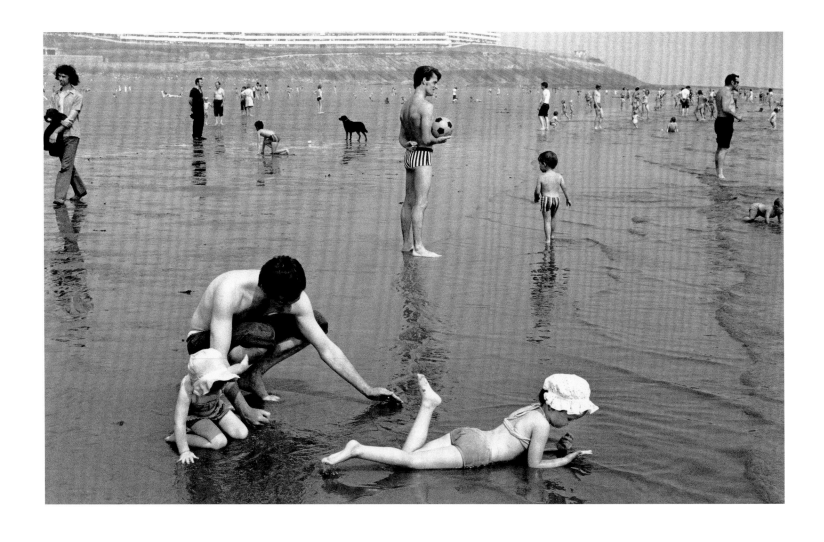

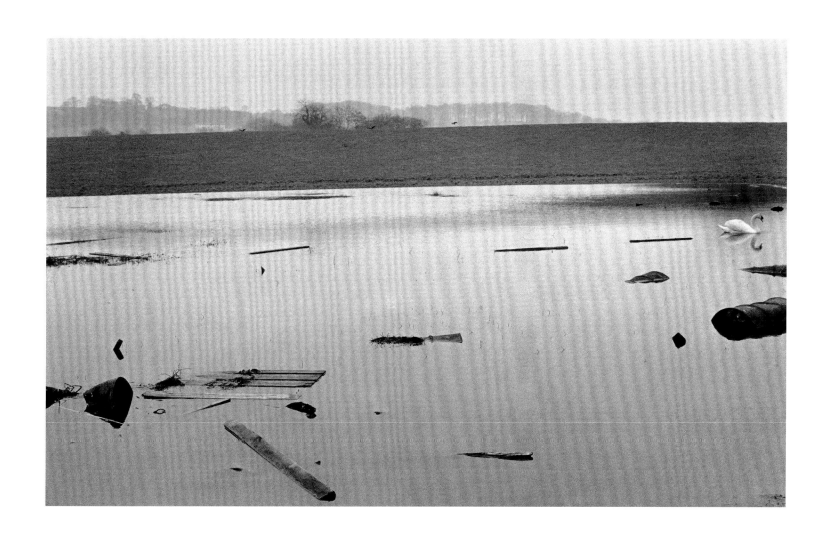

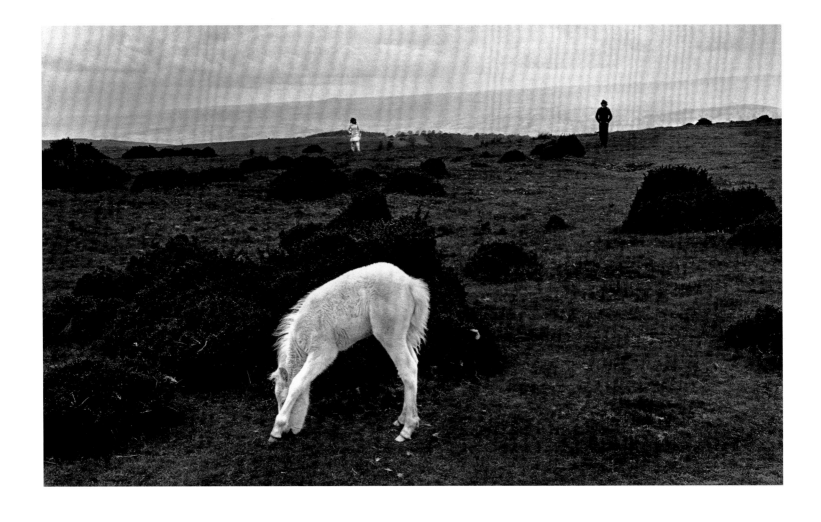

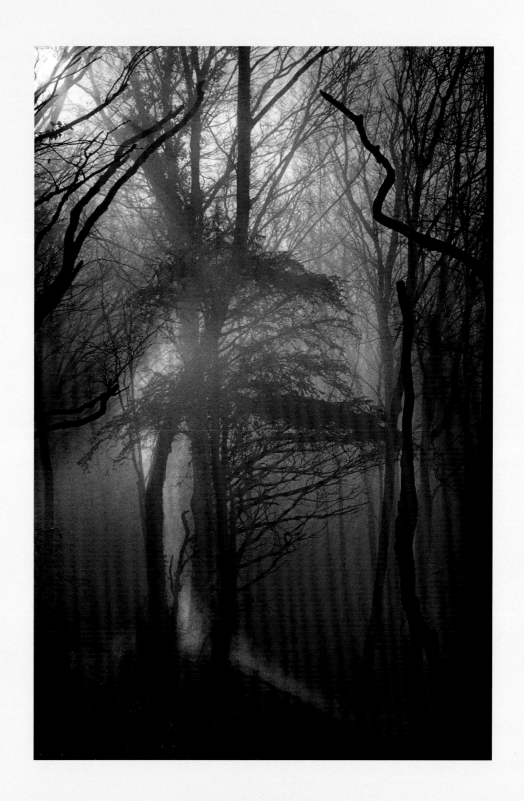

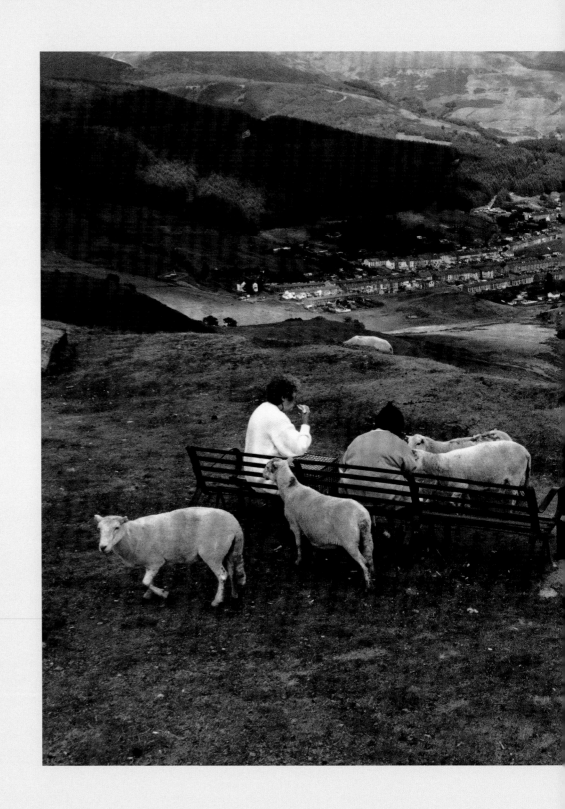

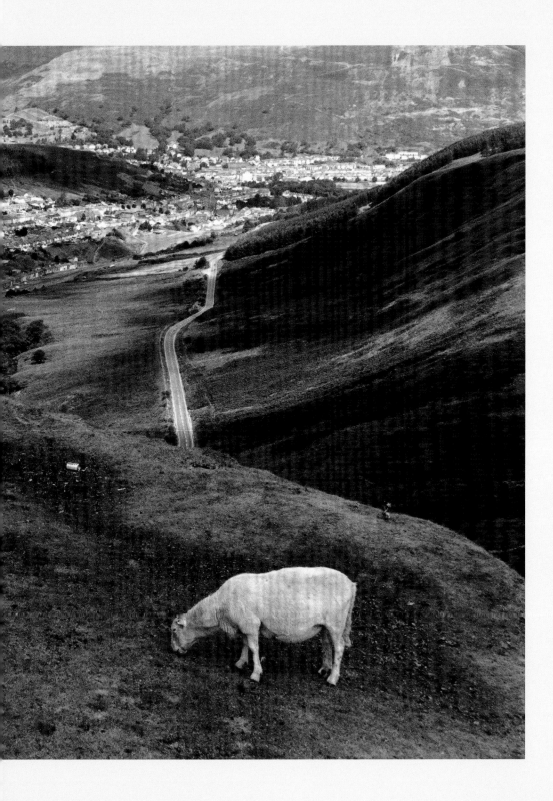

25 Rhondda Valley

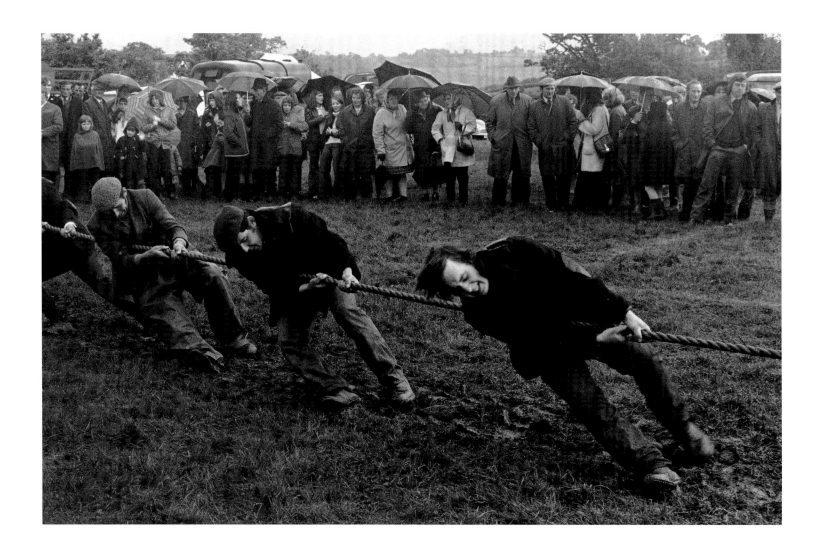

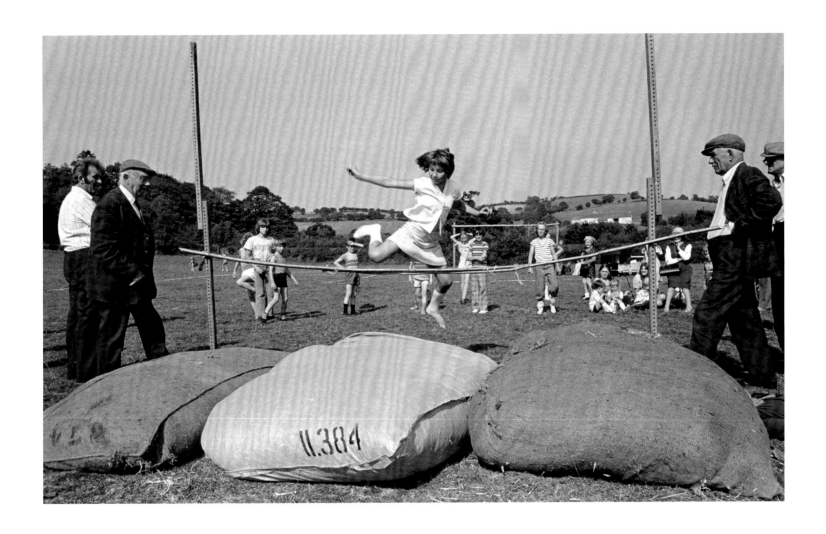

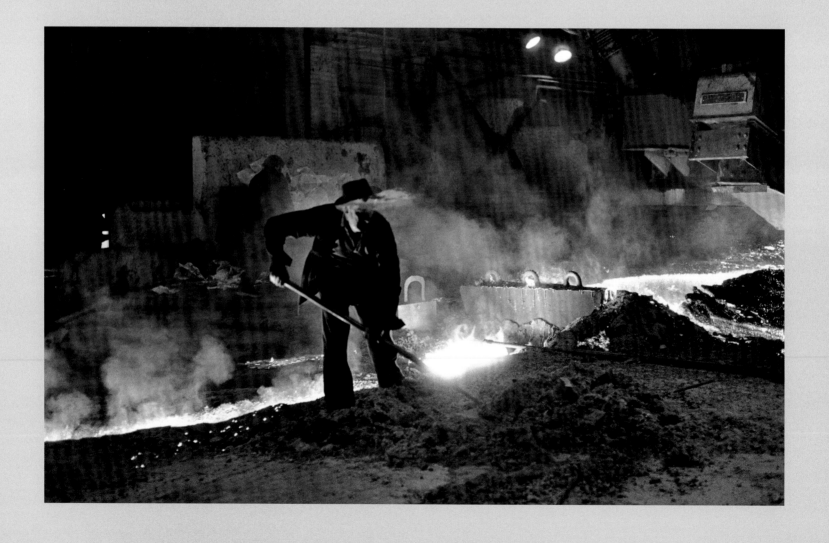

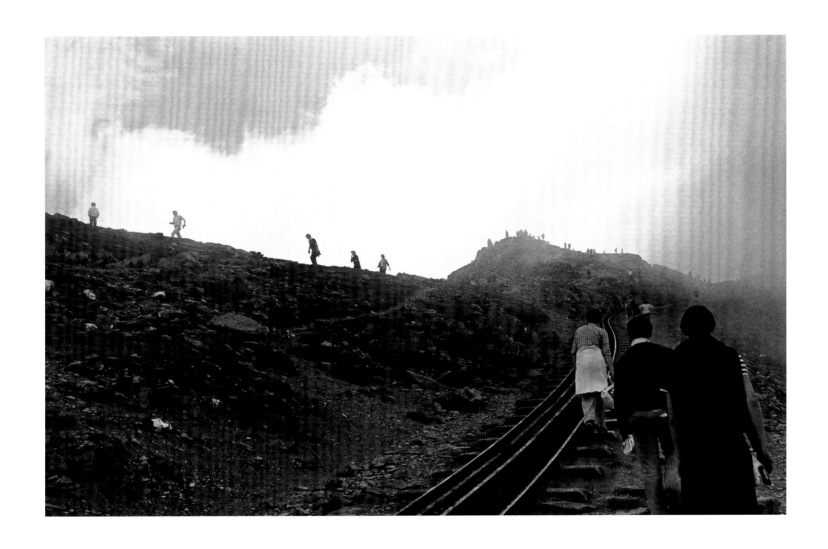

29 Snowdon

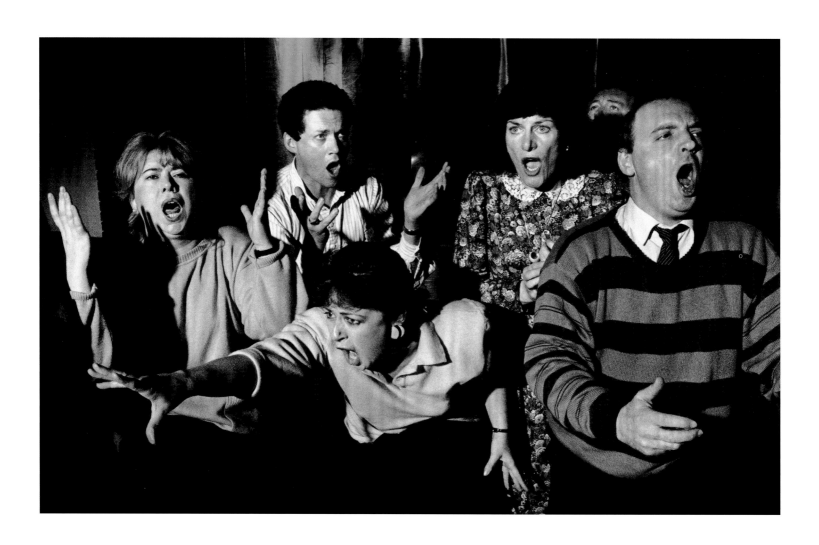

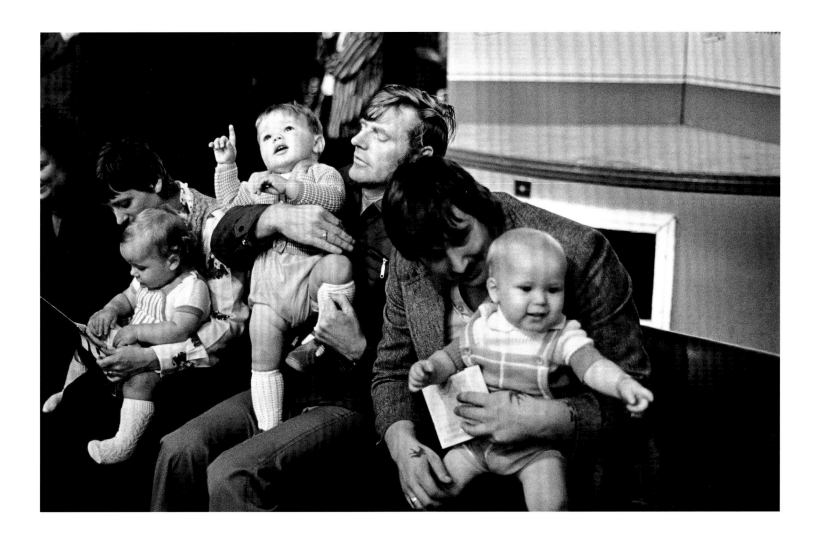

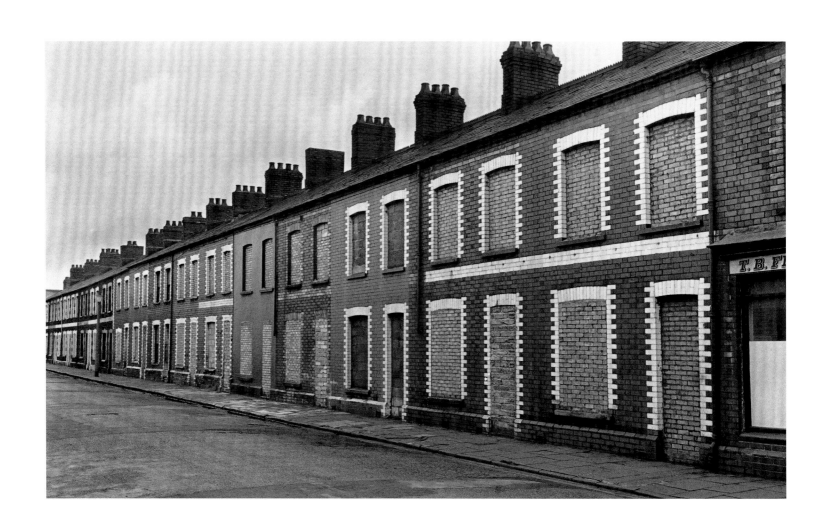

32 Cardiff

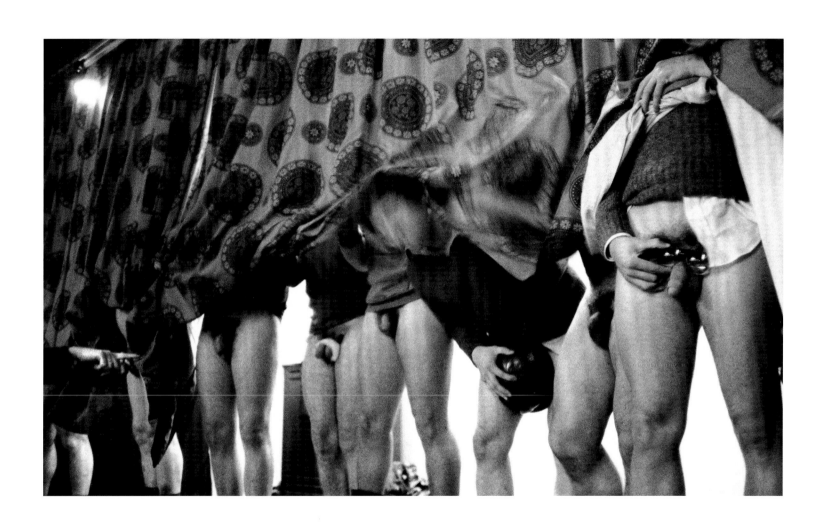

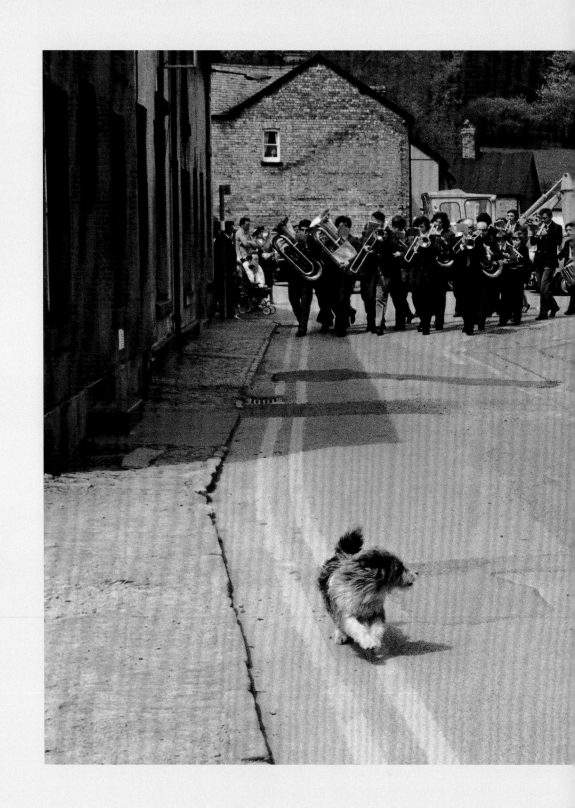

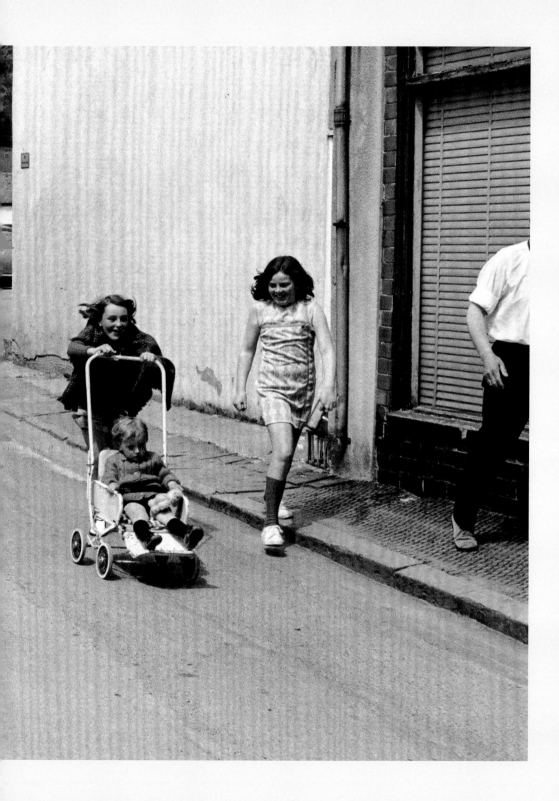

34 Llanidloes

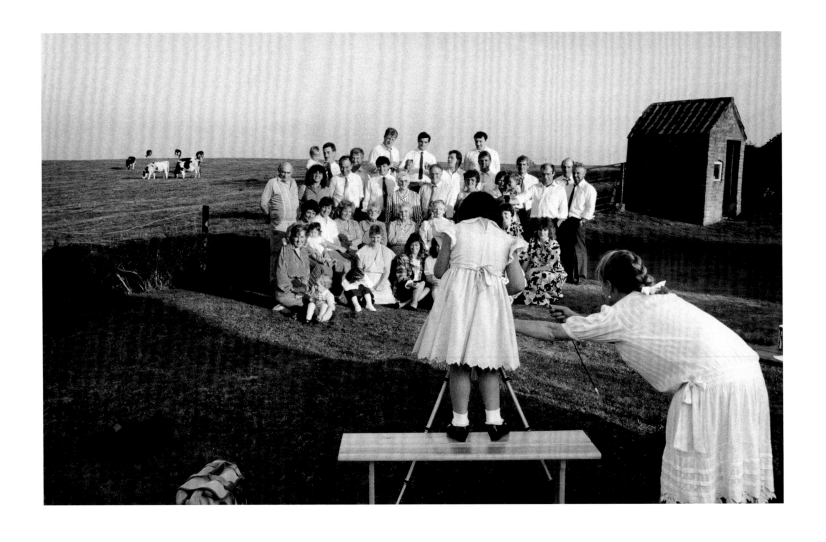

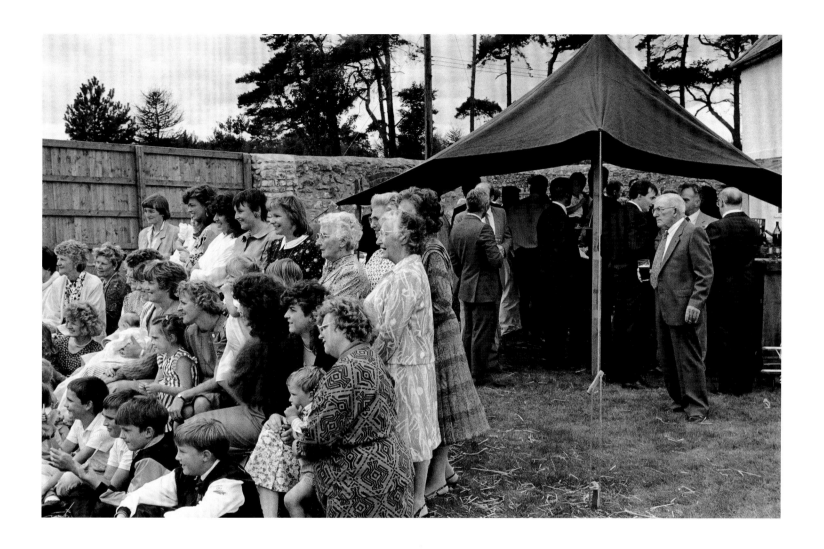

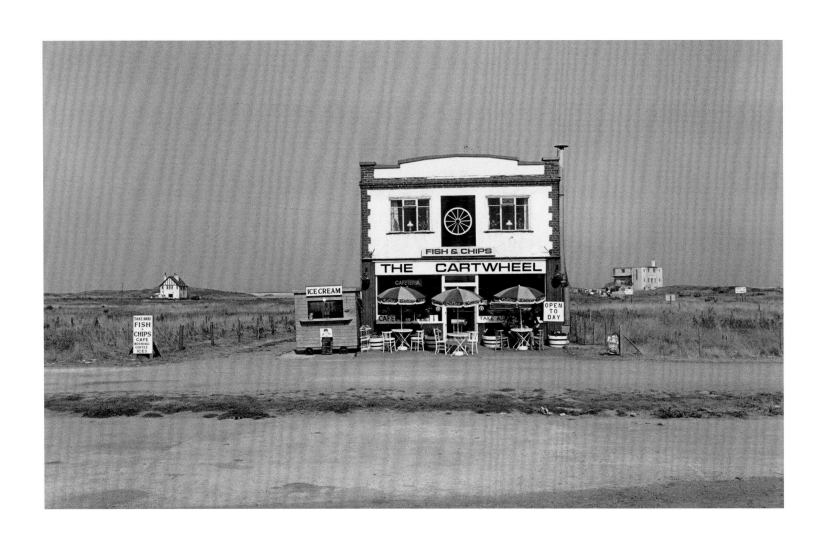

37 Kinmel Bay

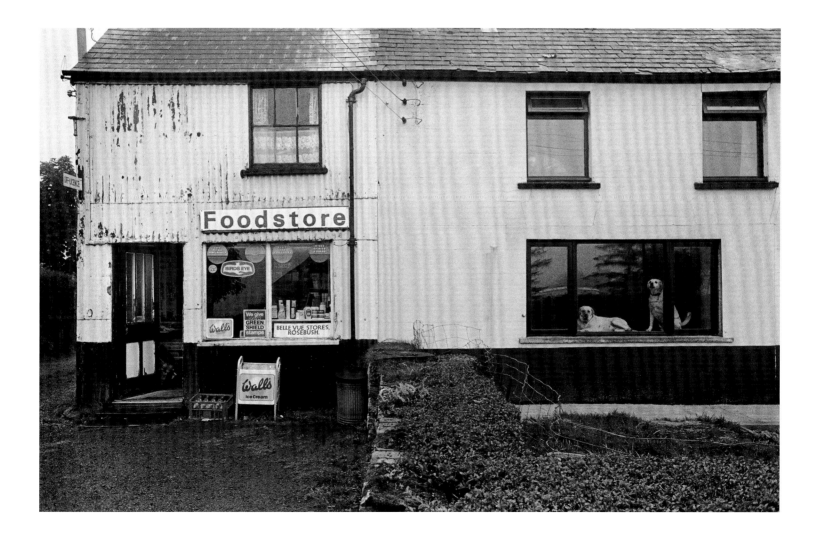

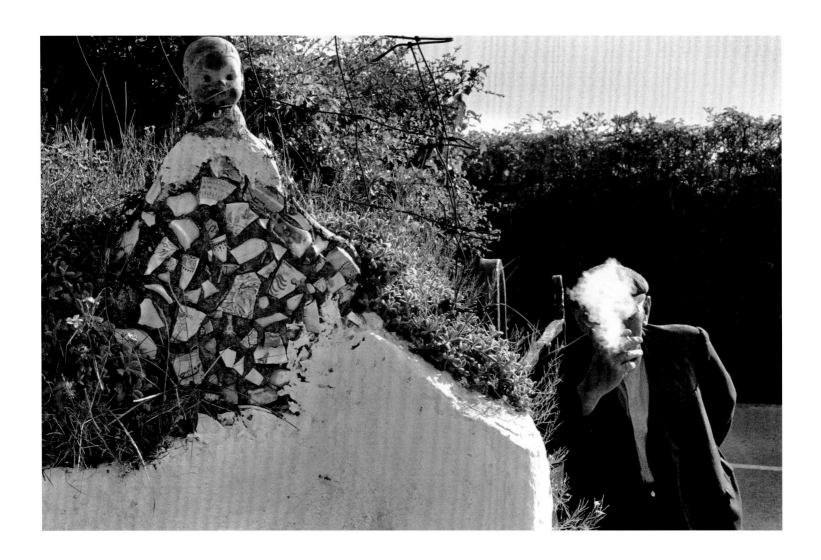

39 Aber Eiddy

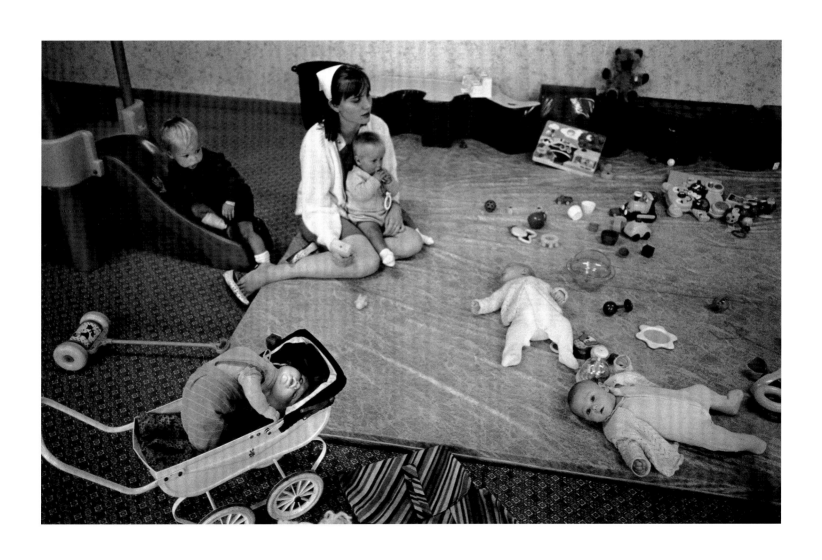

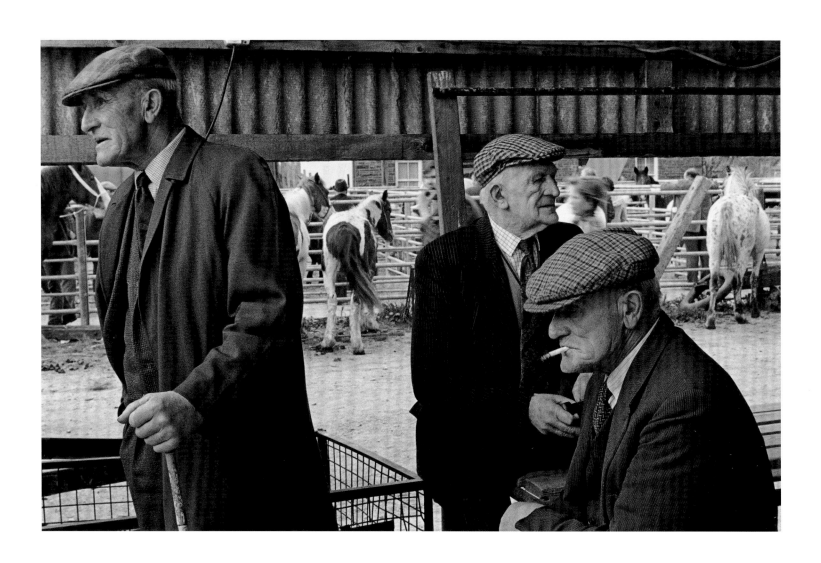

41 Llanybyther

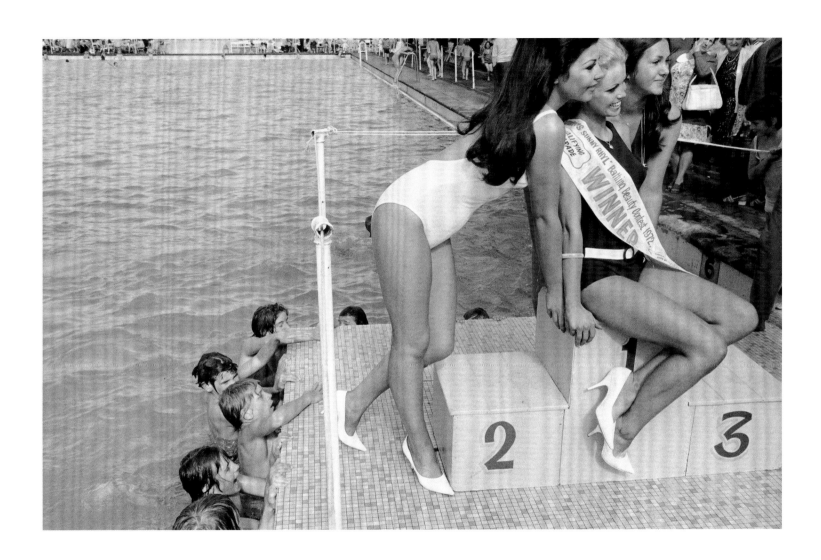

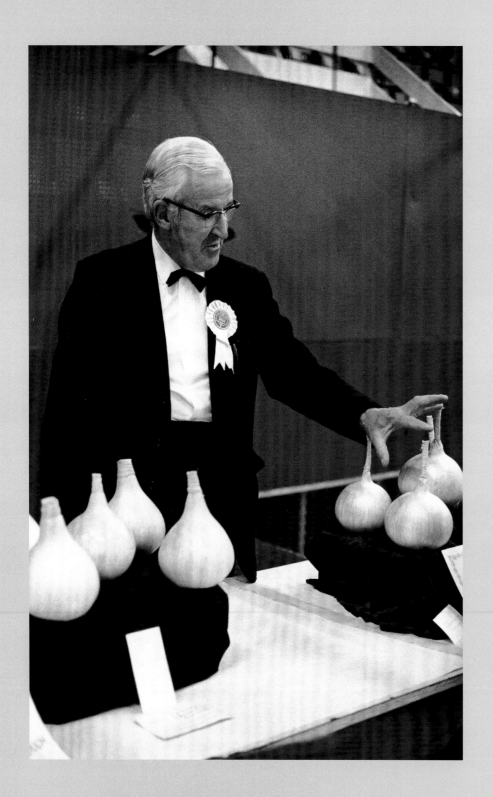

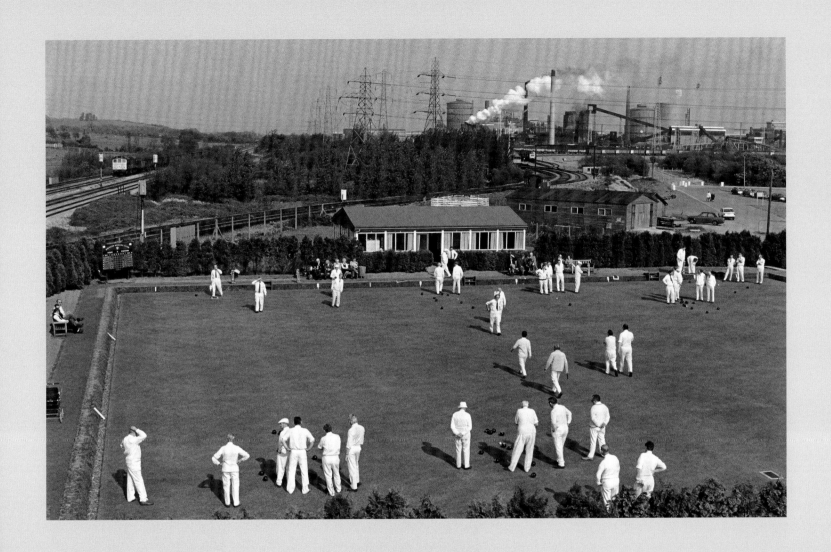

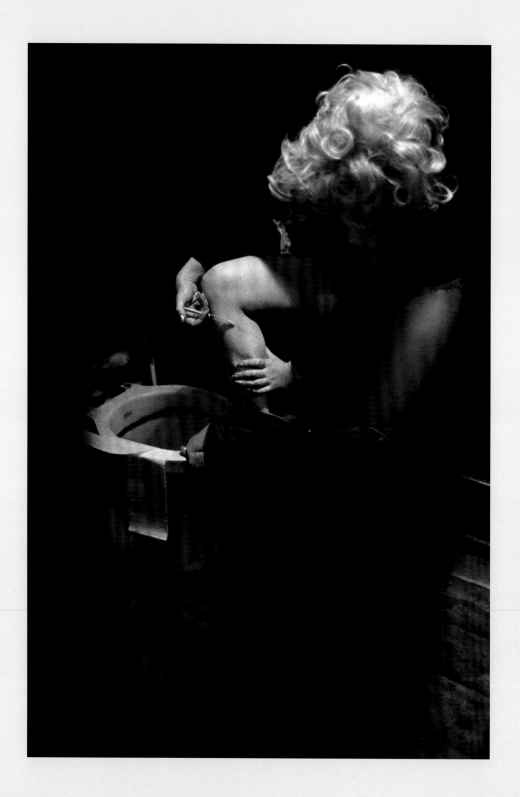

45 Brynmill

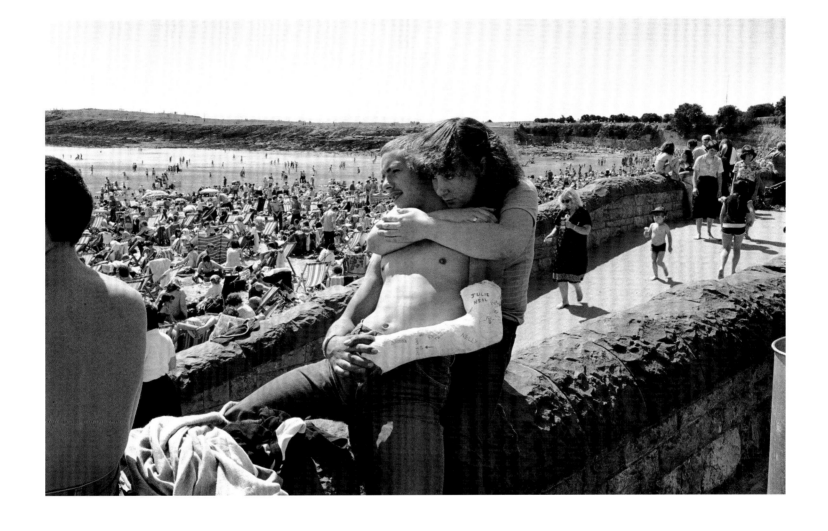

46 Barry Island

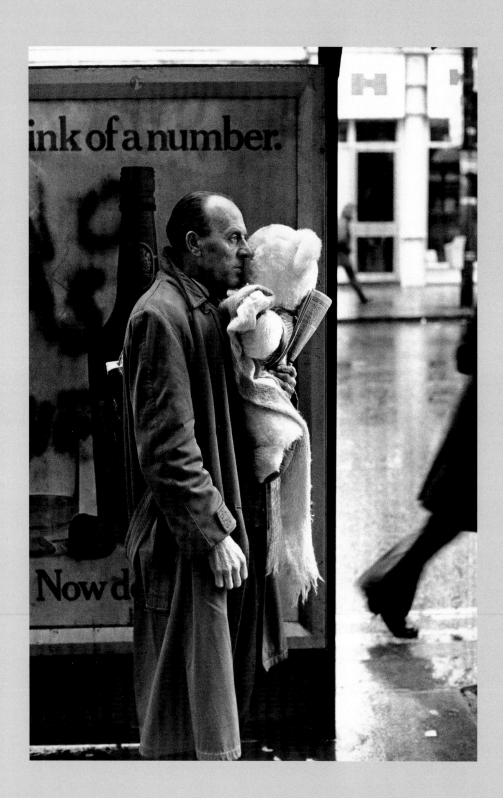

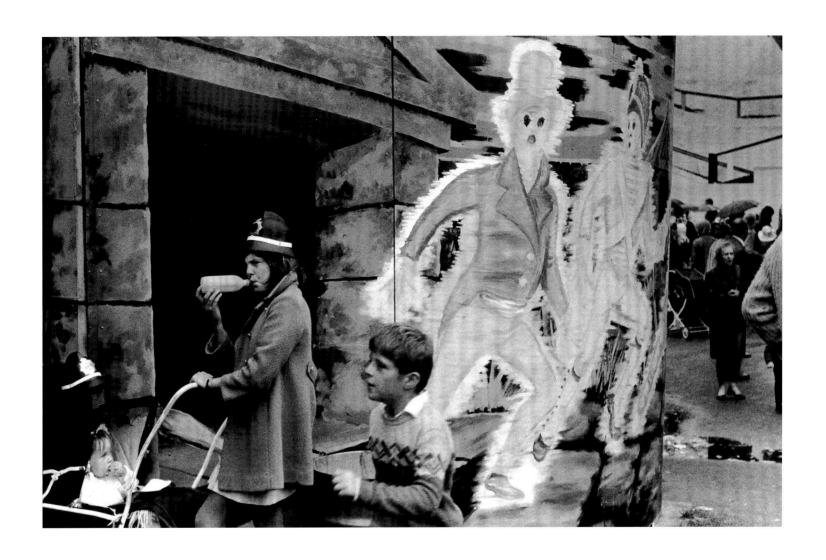

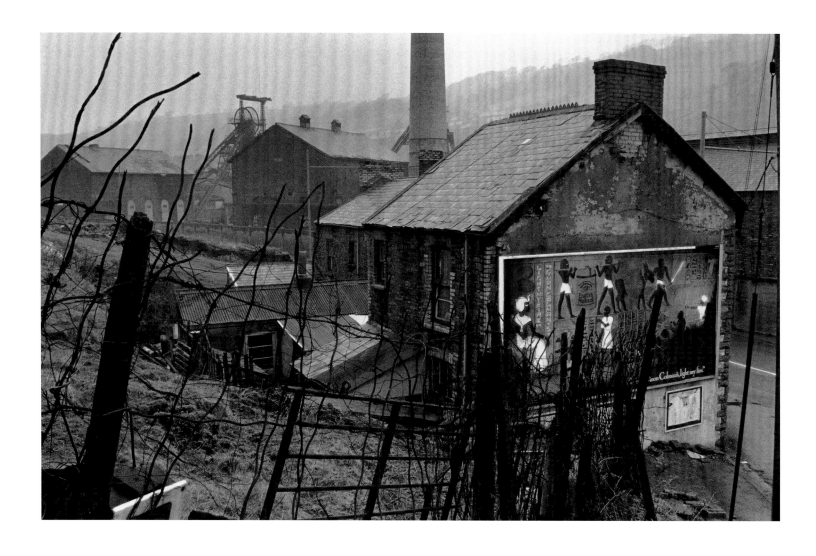

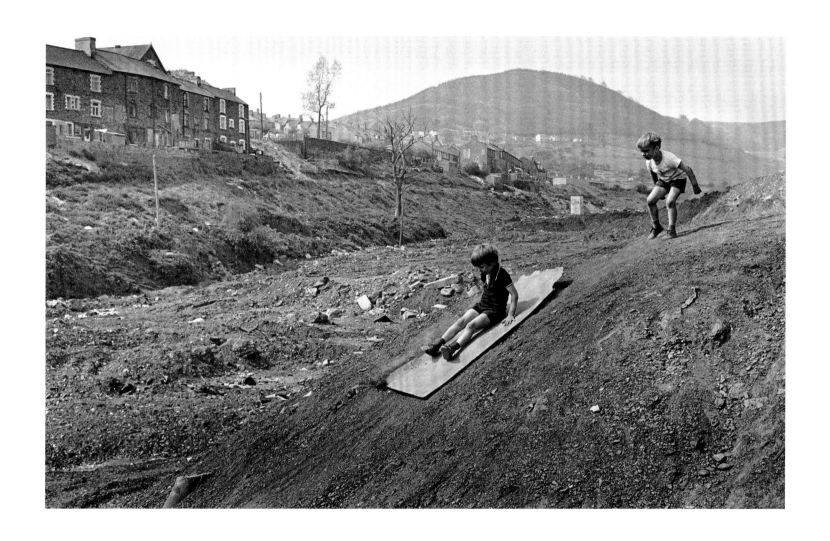

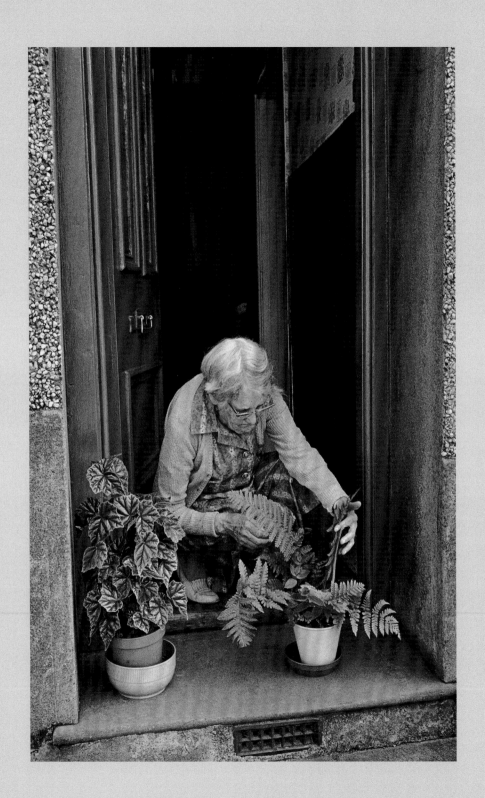

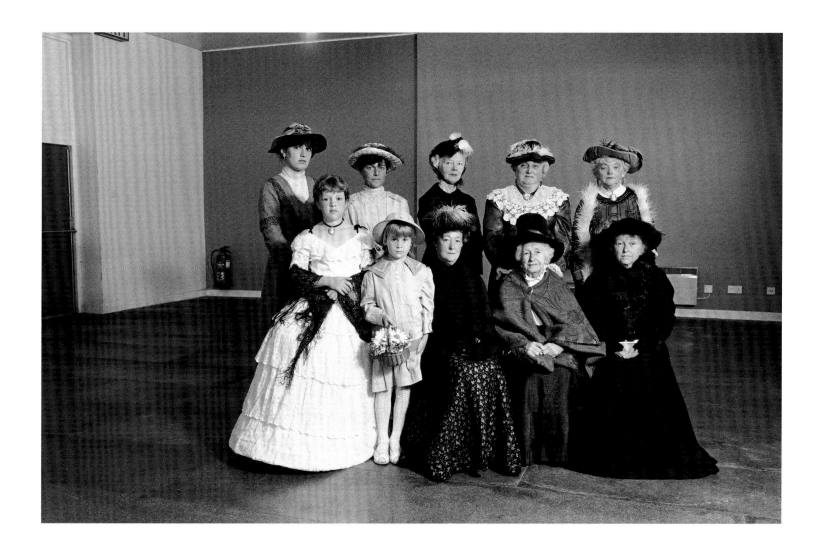

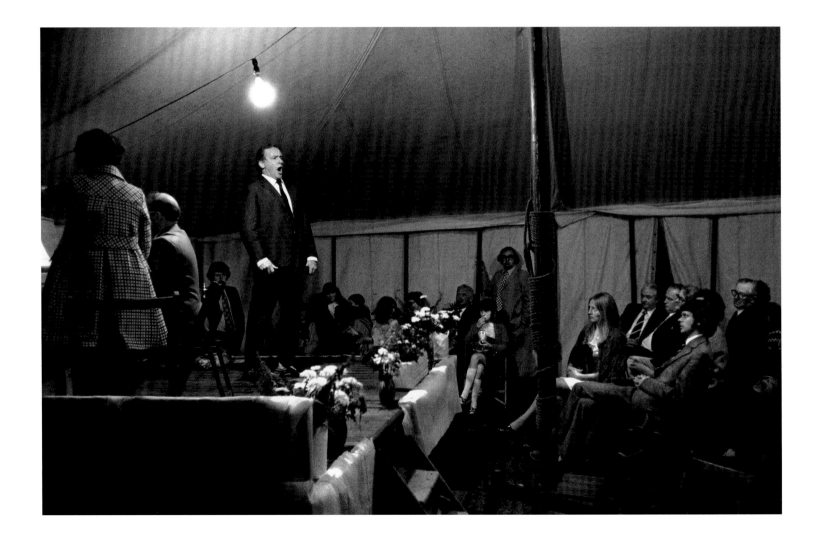

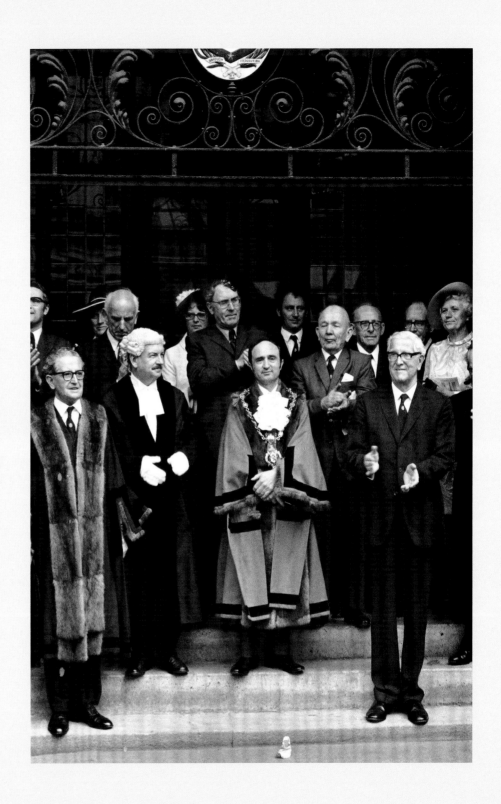

54 Llanidloes

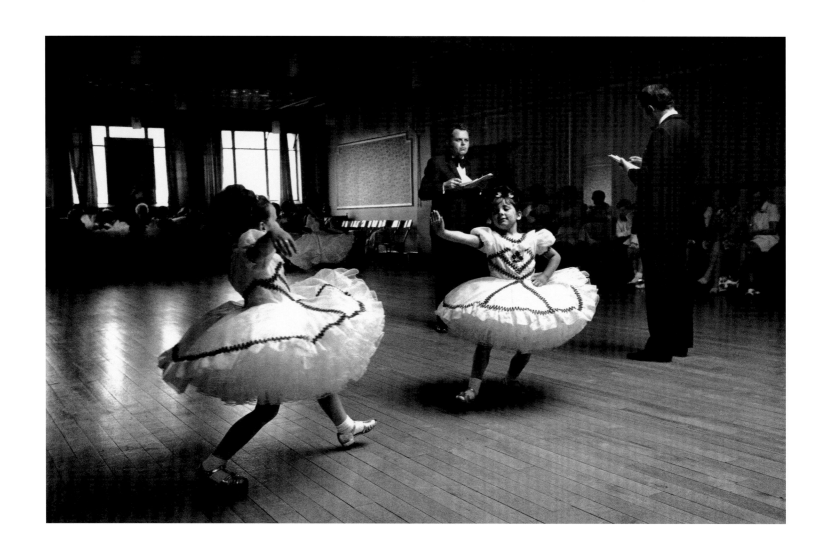

55 Bargoed

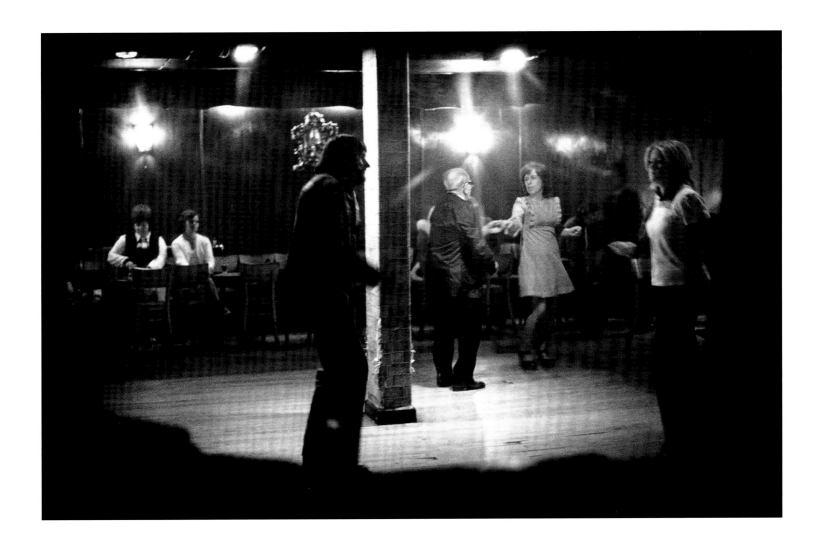

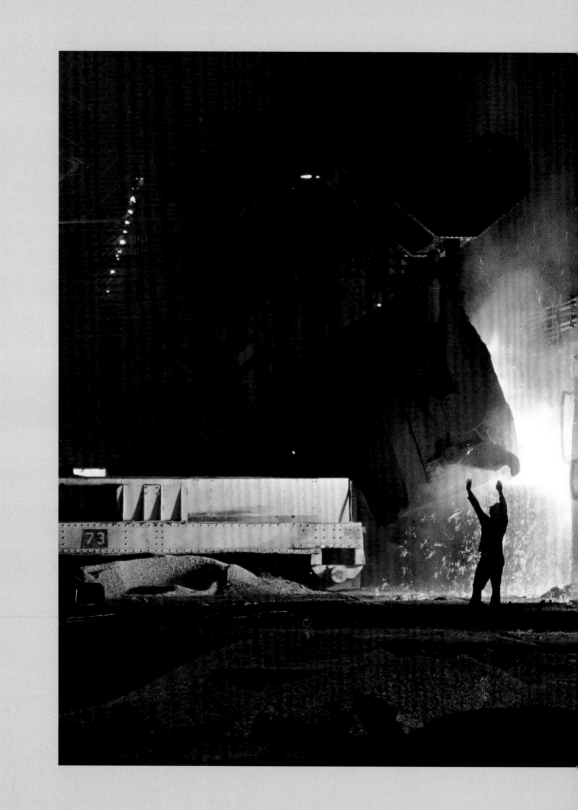

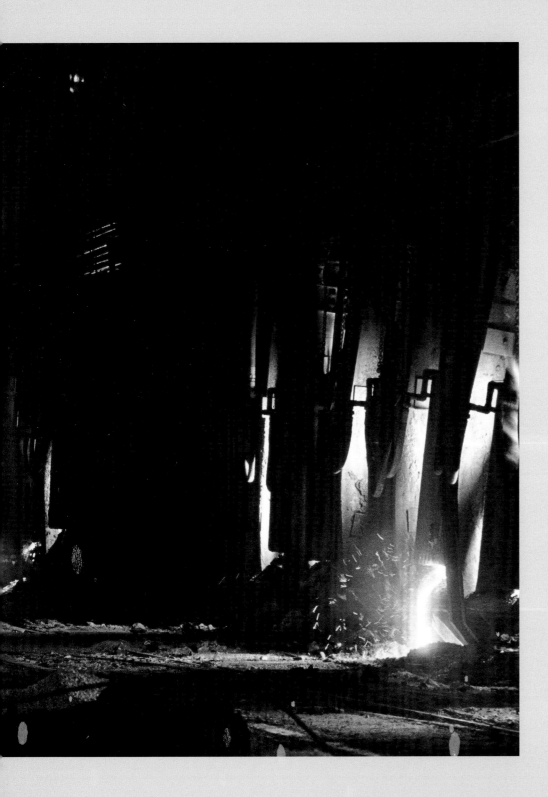

57 Llanwern

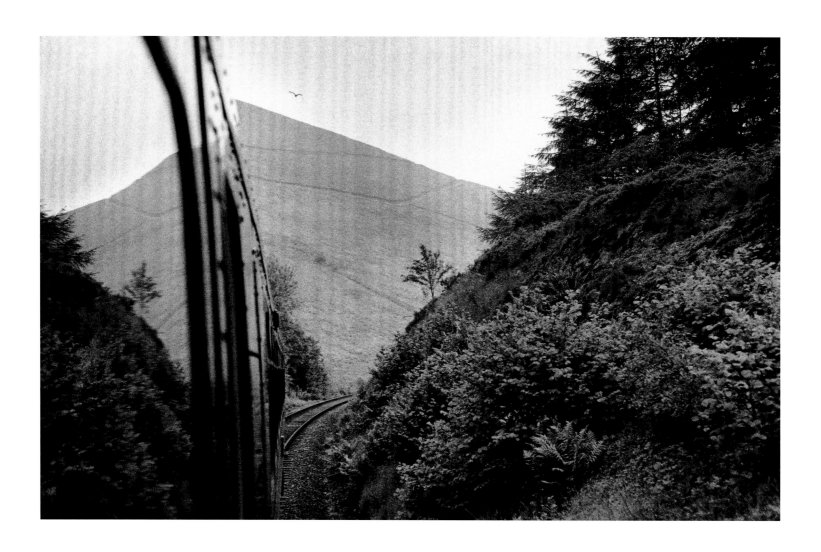

58 Cynghordy

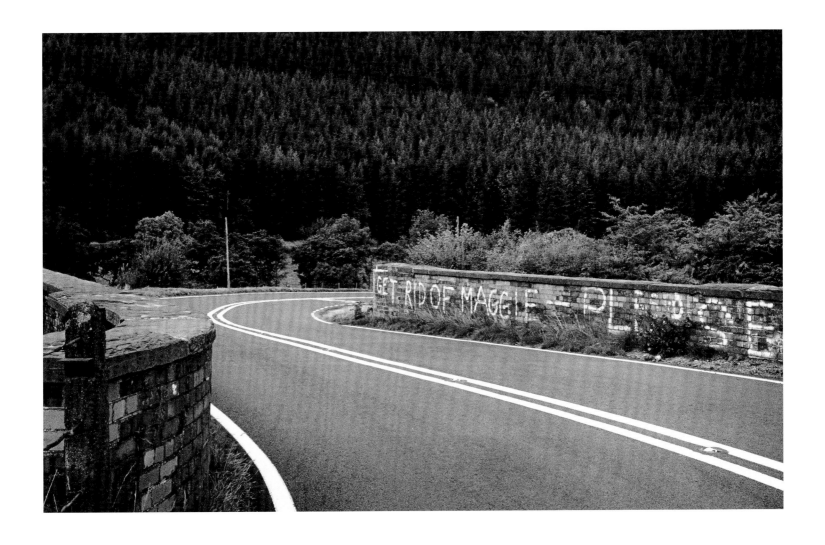

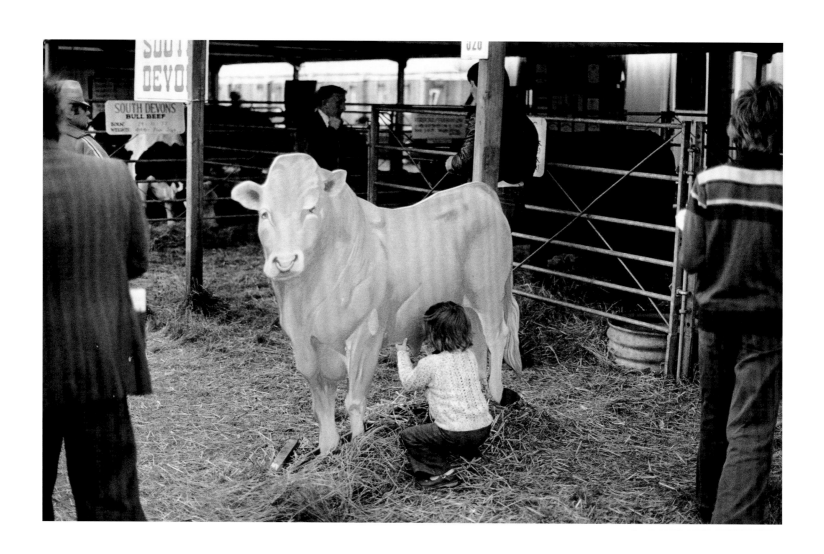

60 Builth Wells

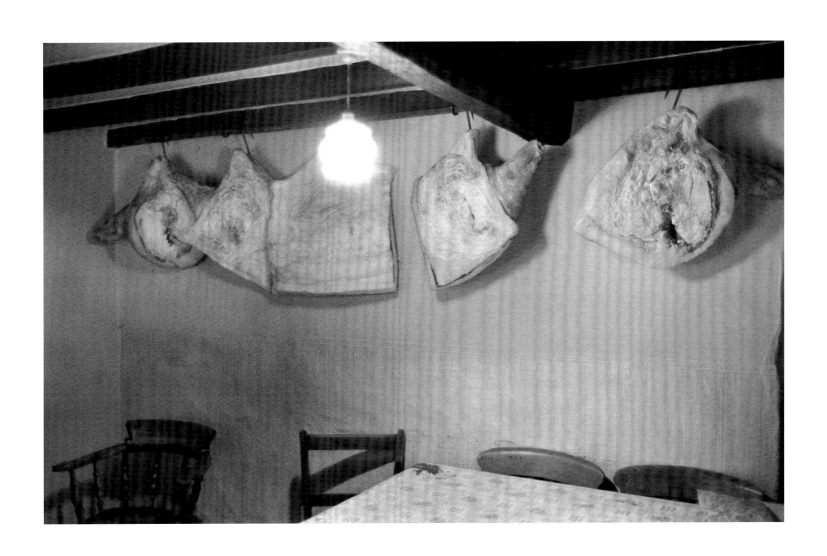

61 Upper Chapel

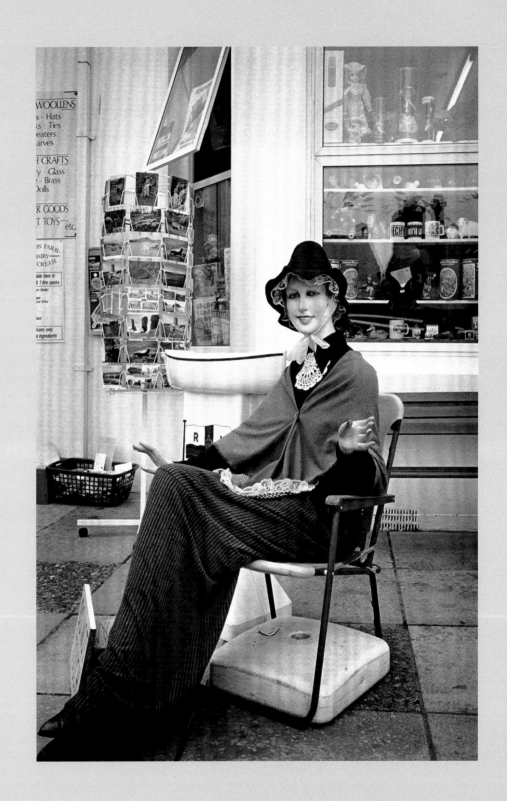

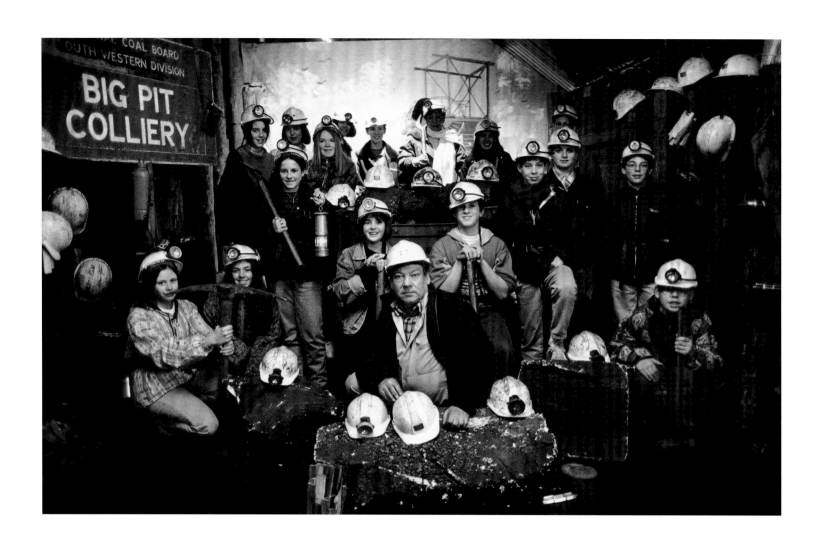

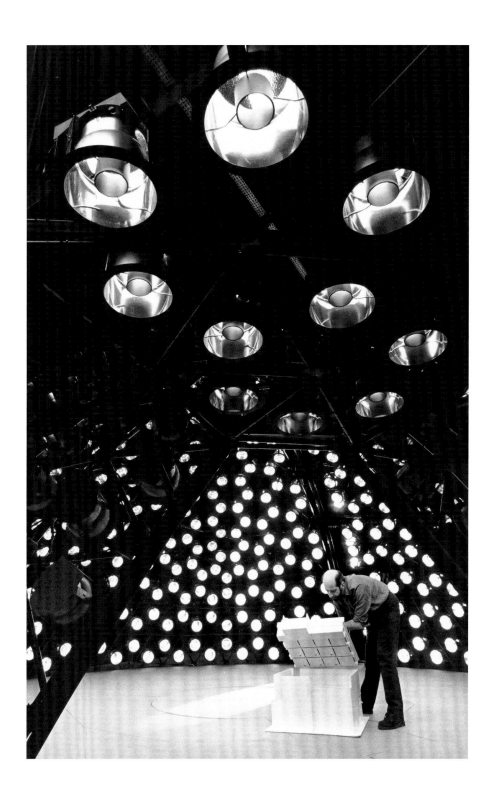

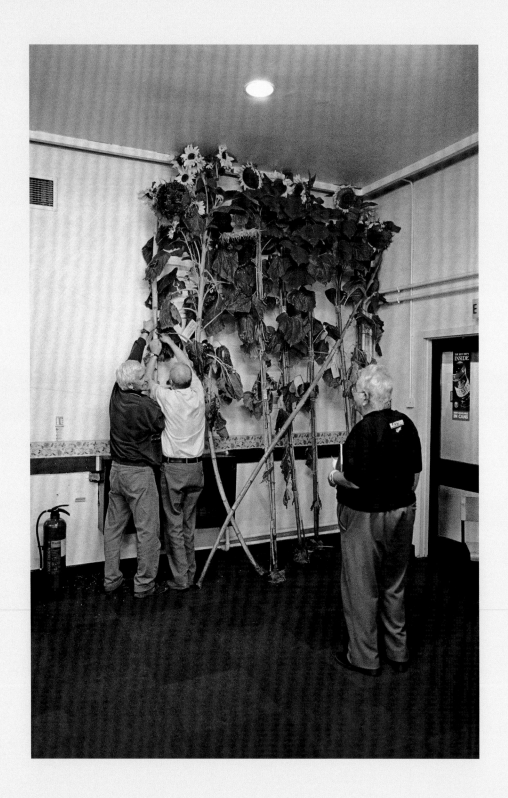

65 Llanharry

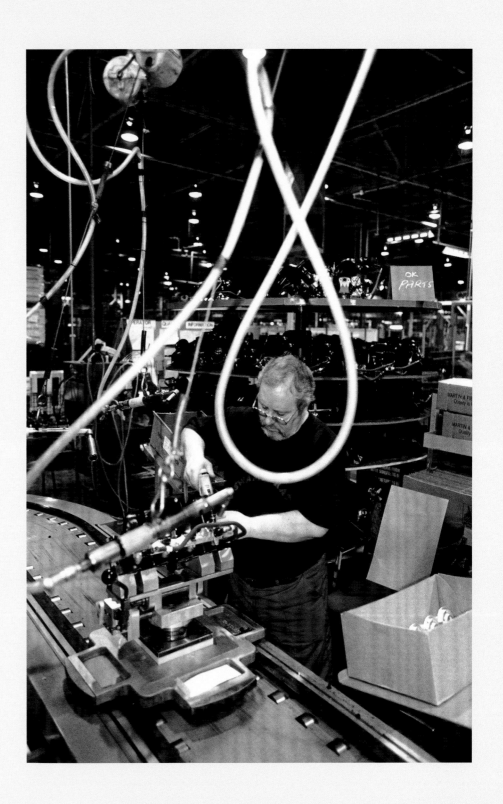

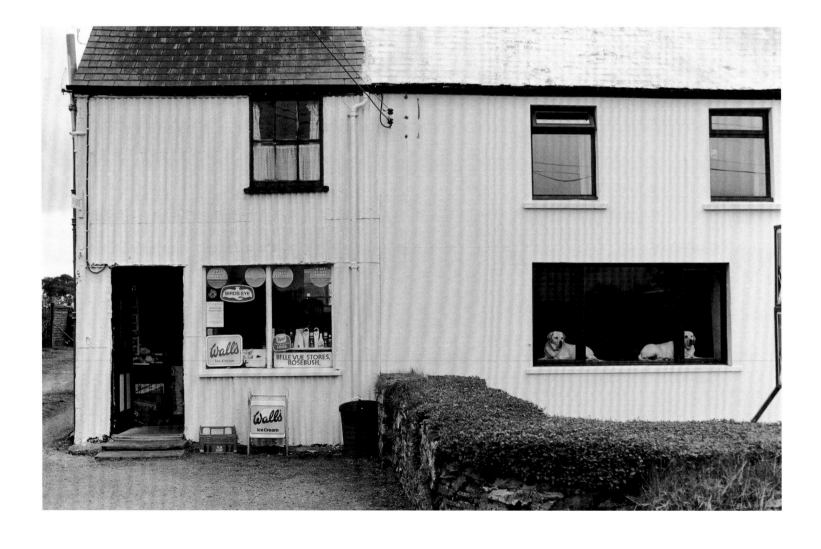

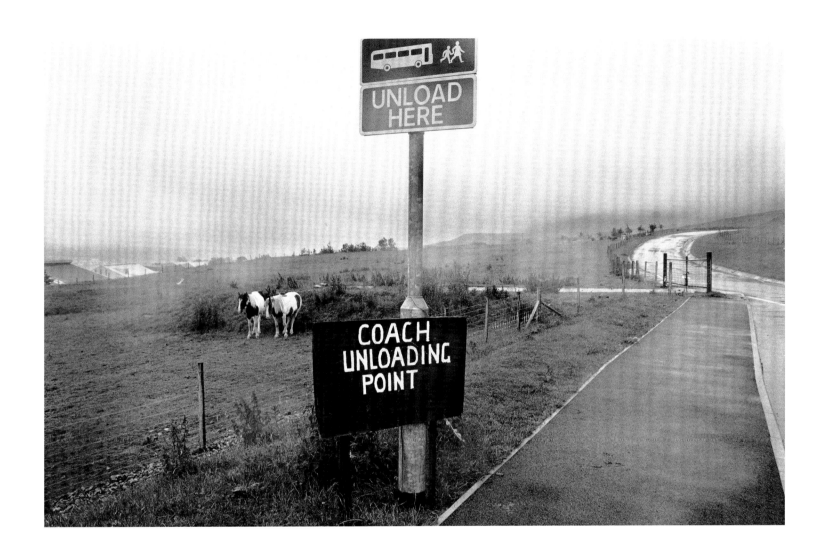

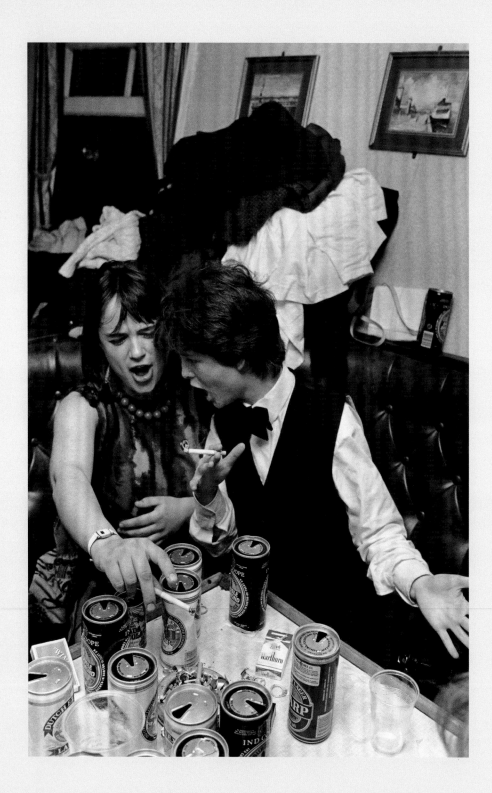

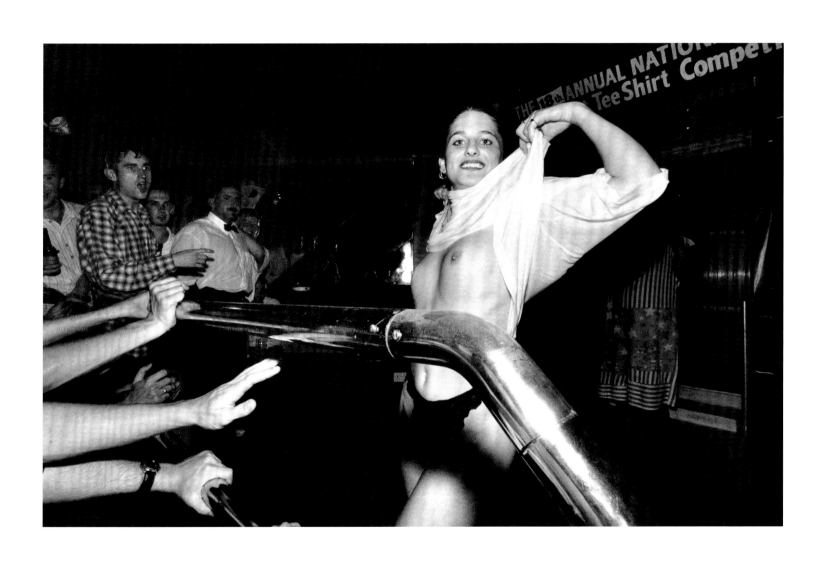

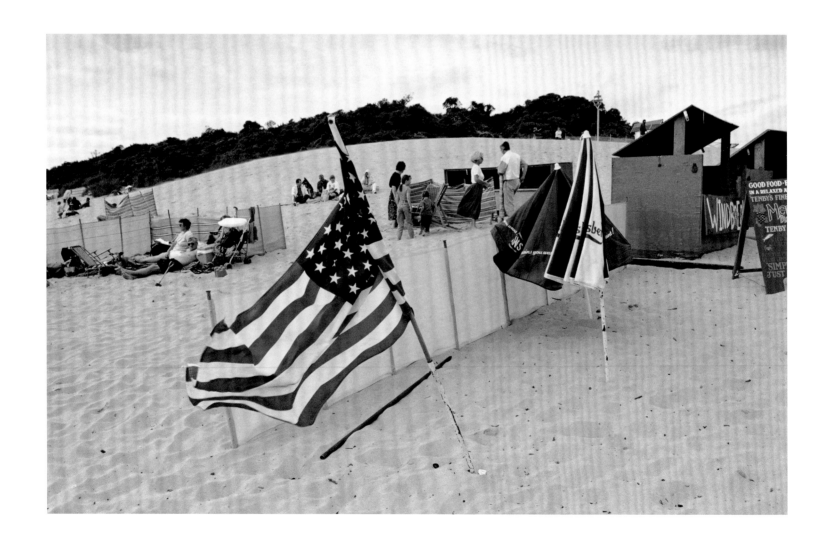

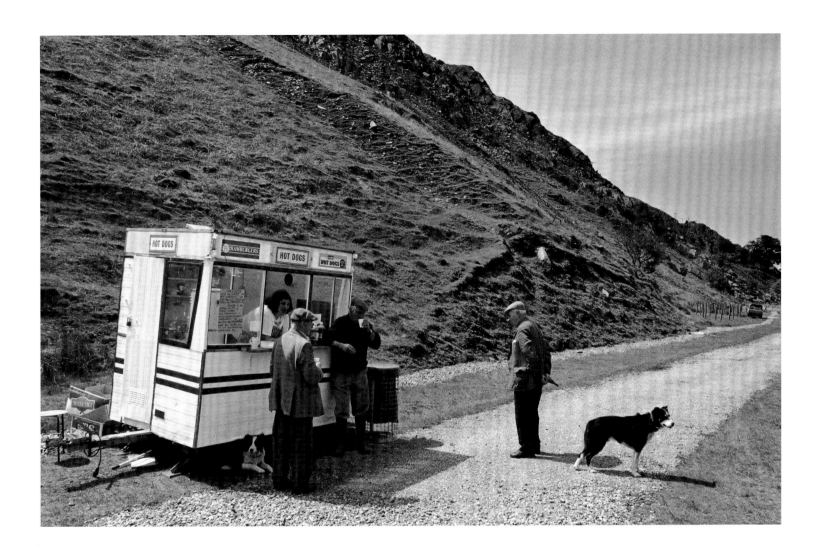

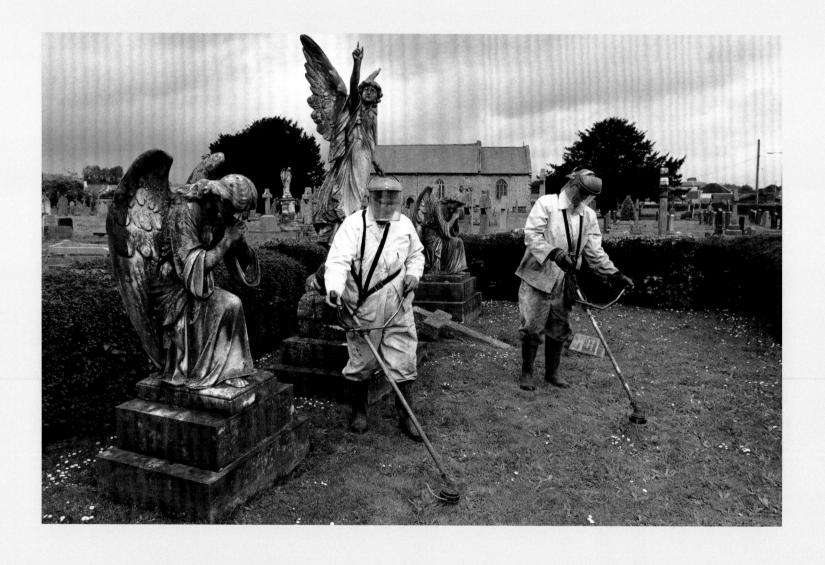

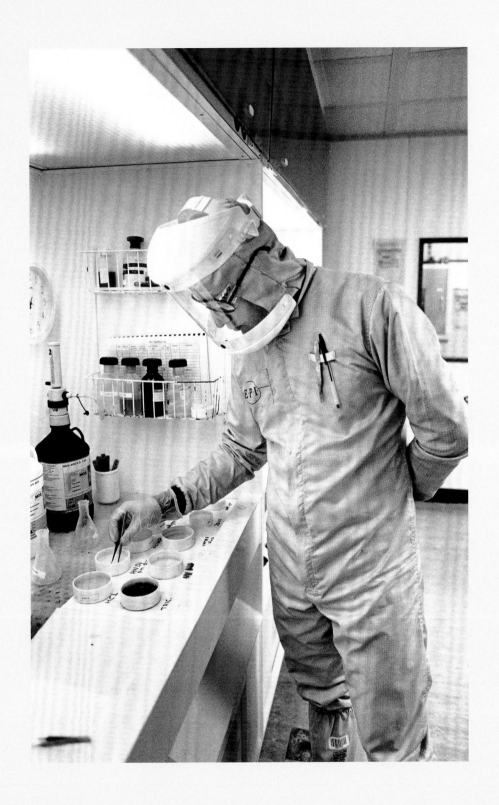

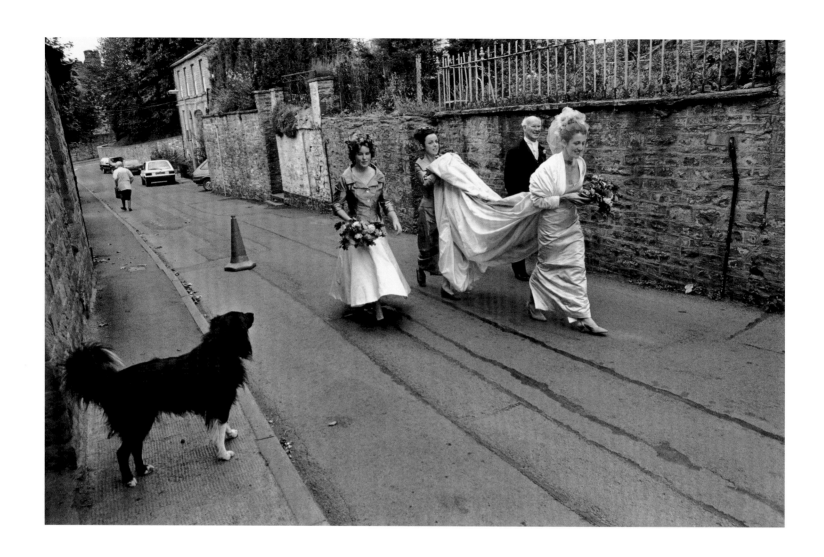

75 Brecon

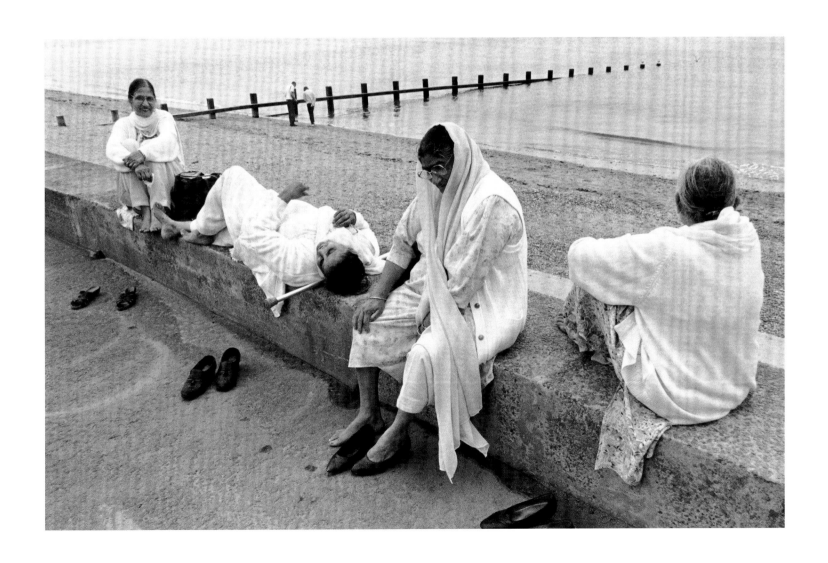

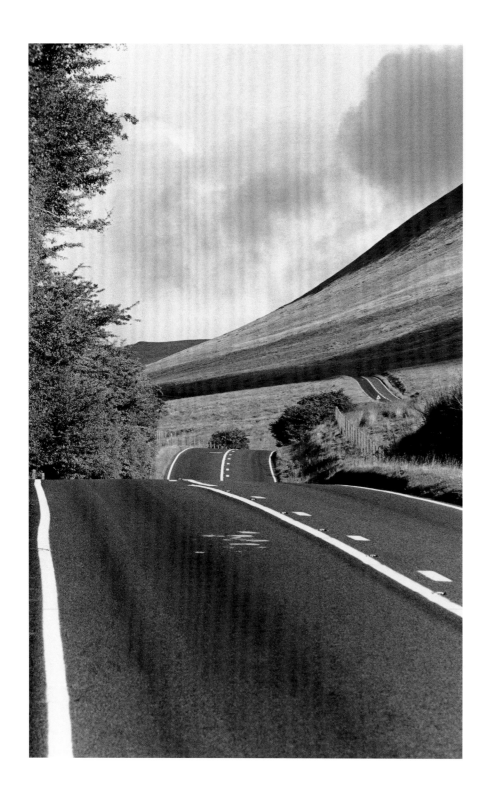

77 Brecon Beacons

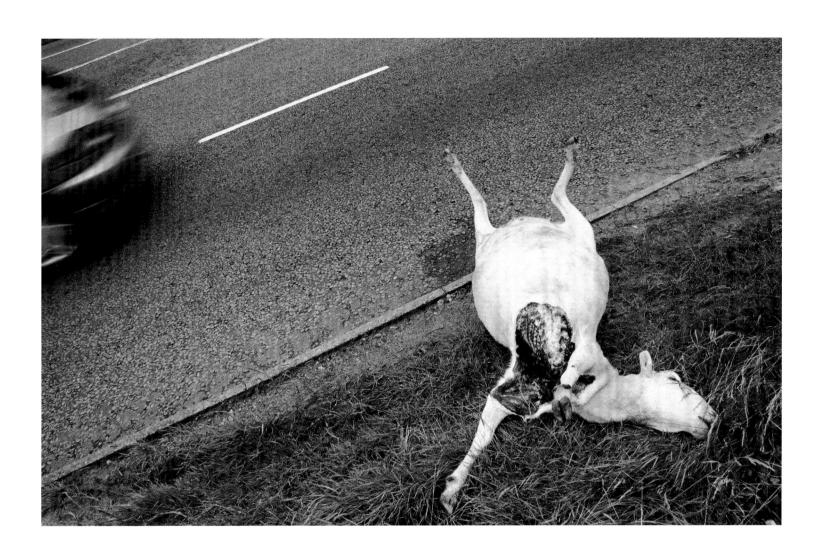

78 Glyn Neath

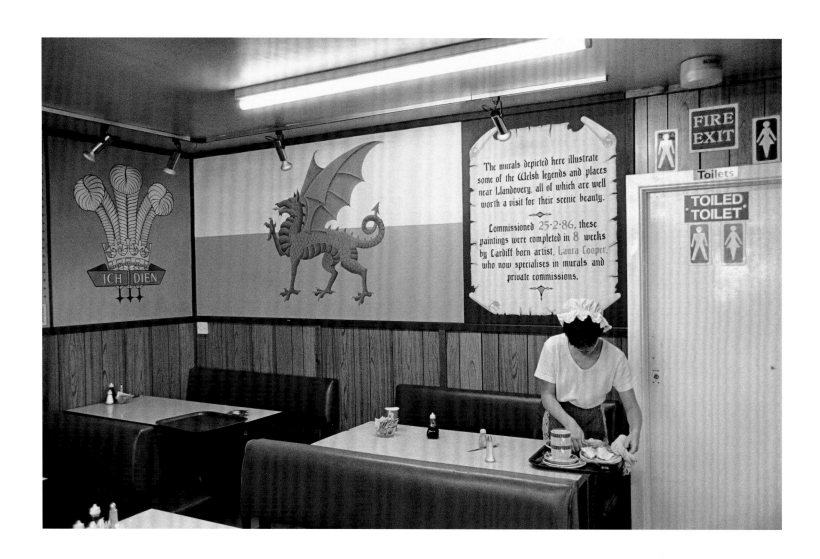

The murals depicted here illustrate some of the Welsh legends and places near Llandovery, all of which are well worth a visit for their scenic beauty.

Commissioned 25·2·86, these paintings were completed in 8 weeks by Cardiff born artist, Laura Cooper, who now specialises in murals and private commissions.

ICH DIEN

FIRE EXIT

Toilets

TOILED TOILET

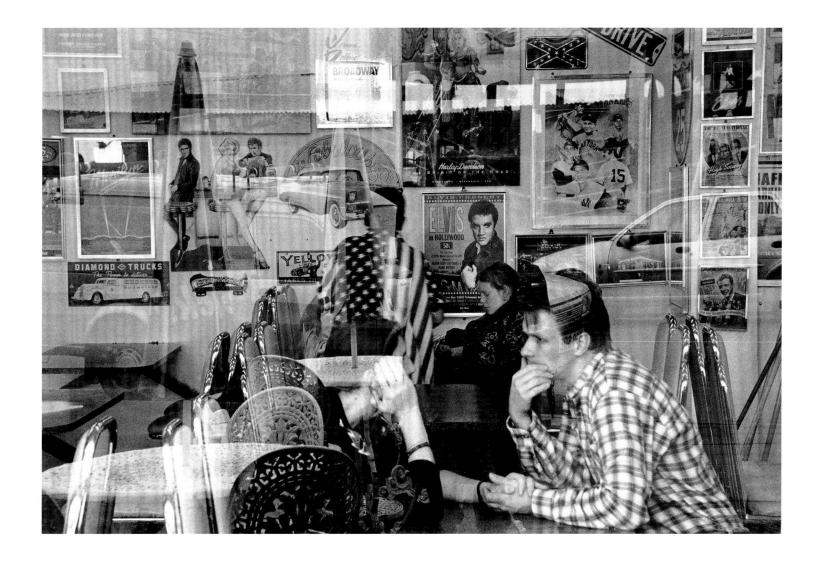

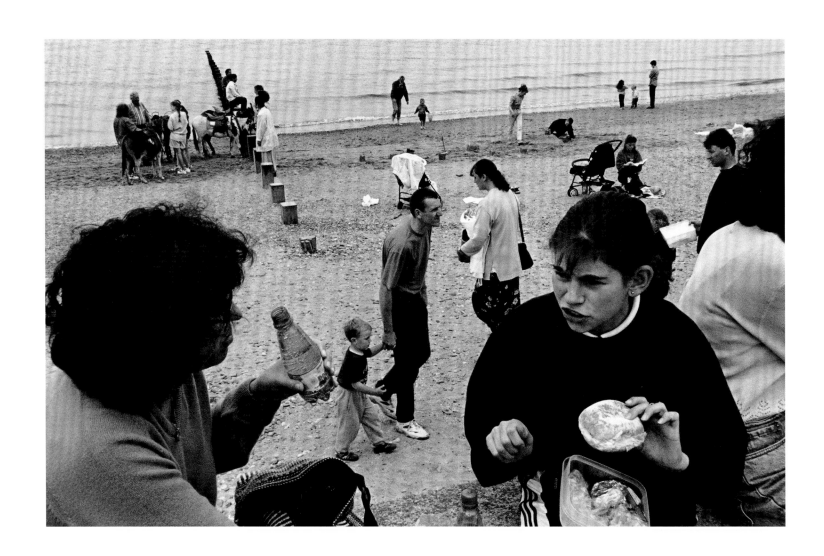

81 Rhyl

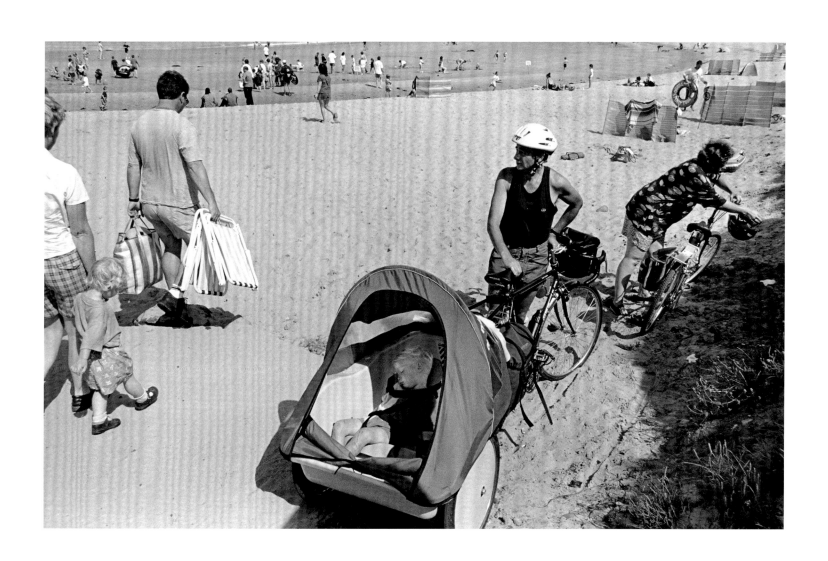

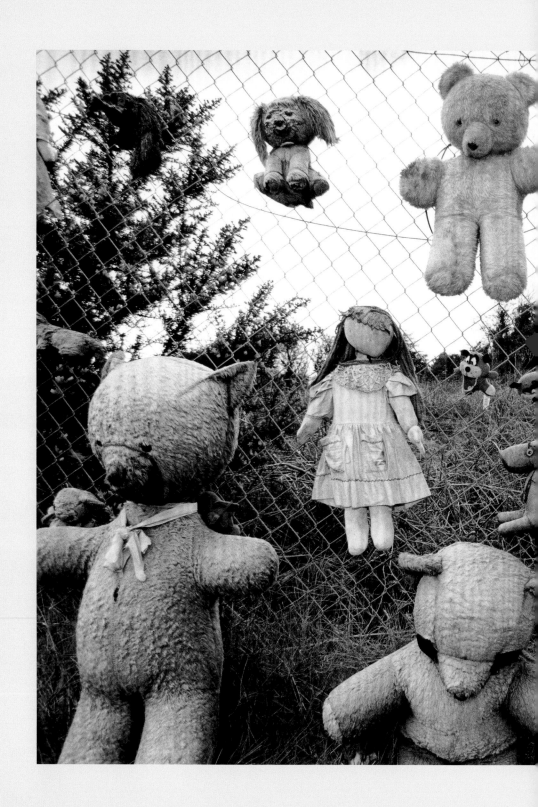

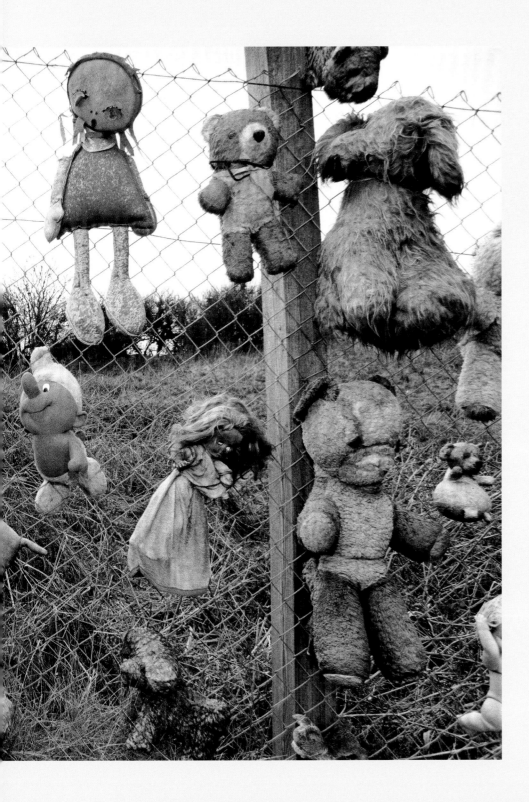

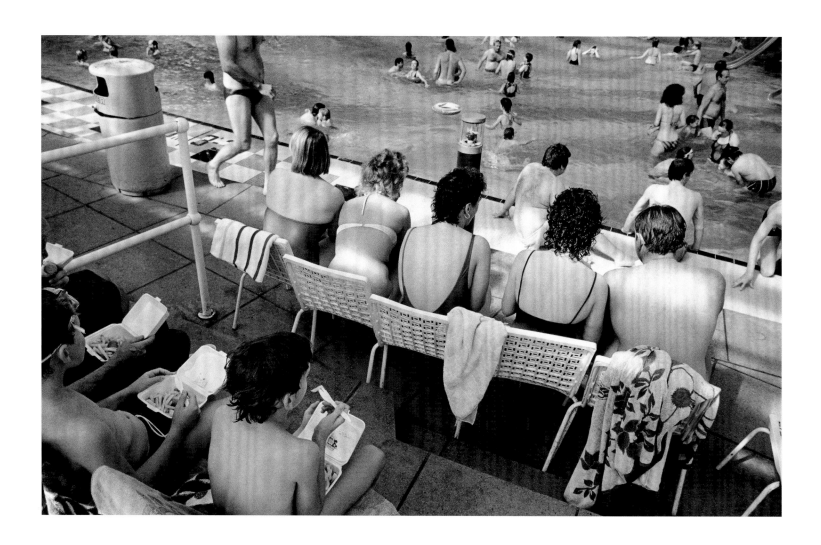

84 Rhyl

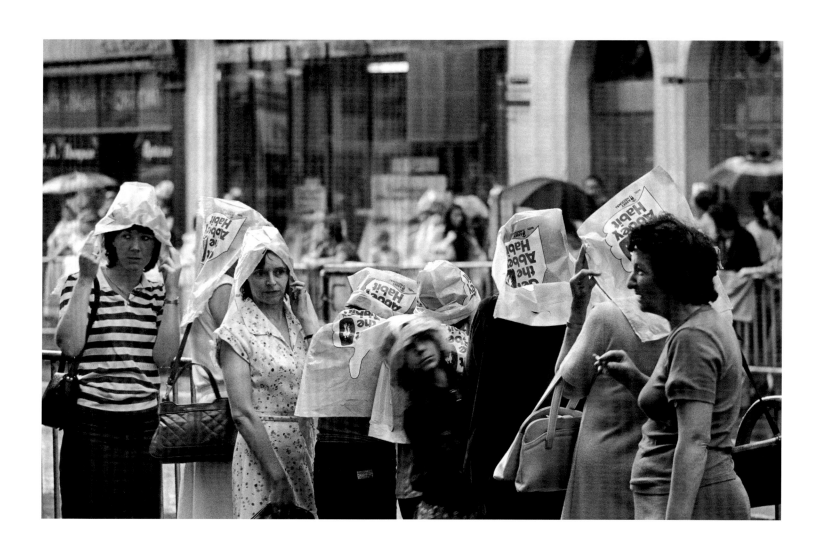

85 Cardiff

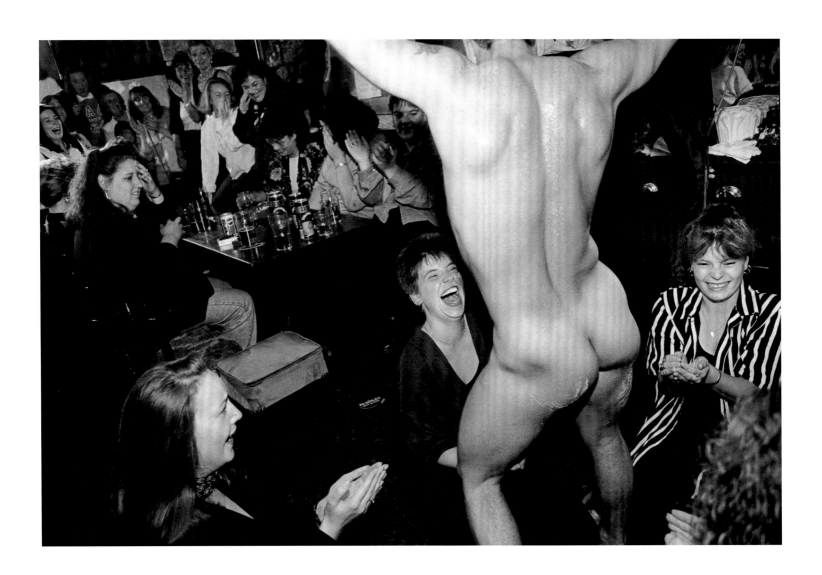

86 Usk

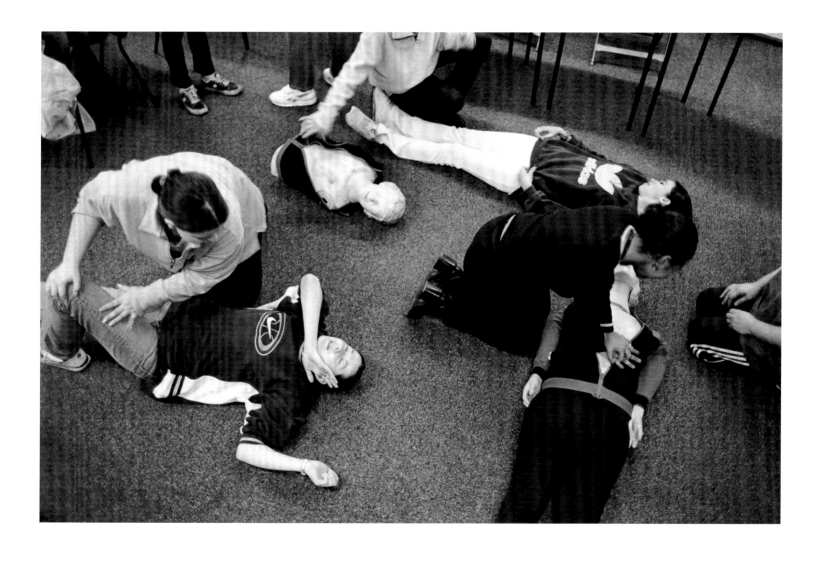

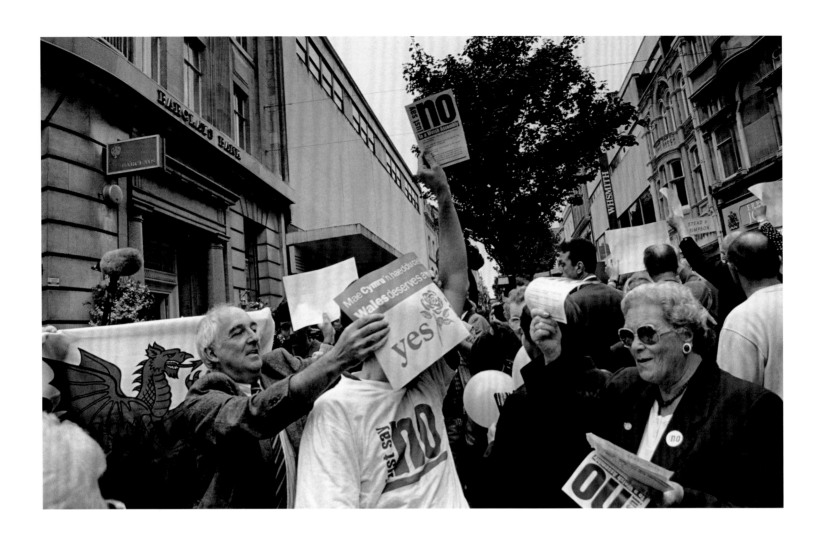

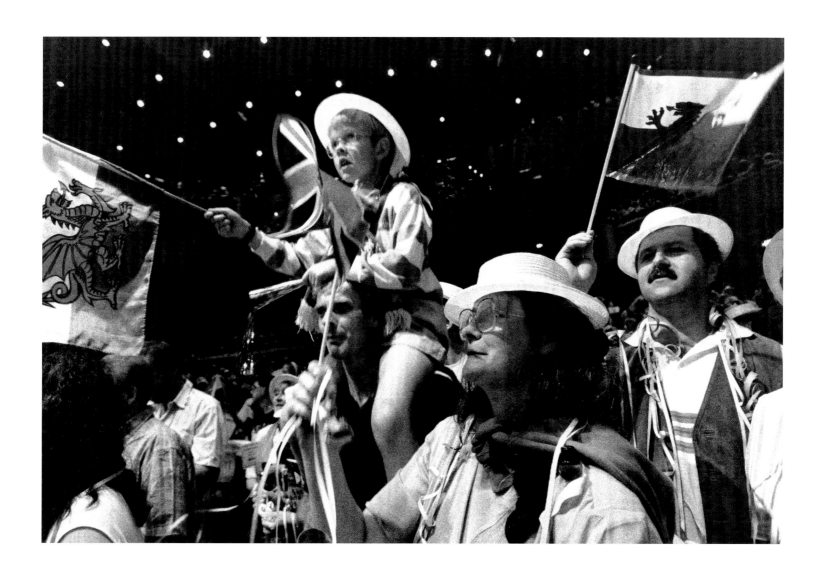

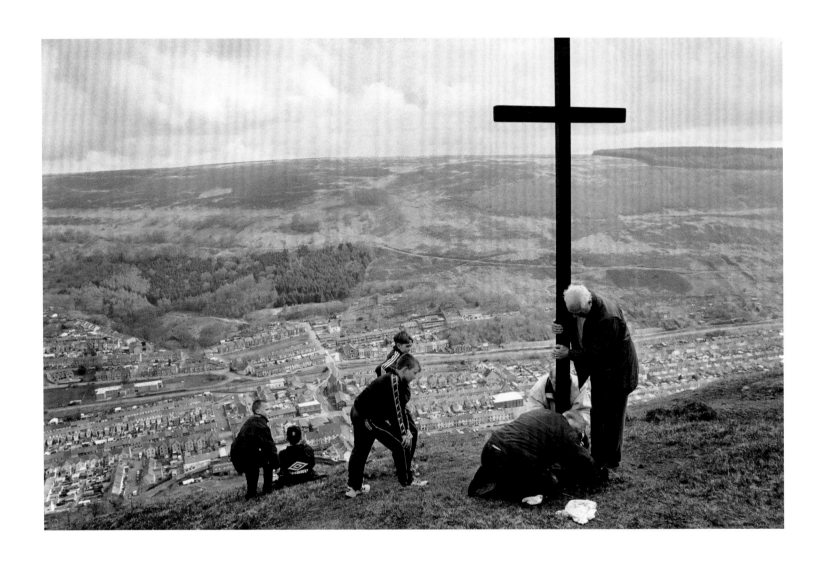

90 Cwm

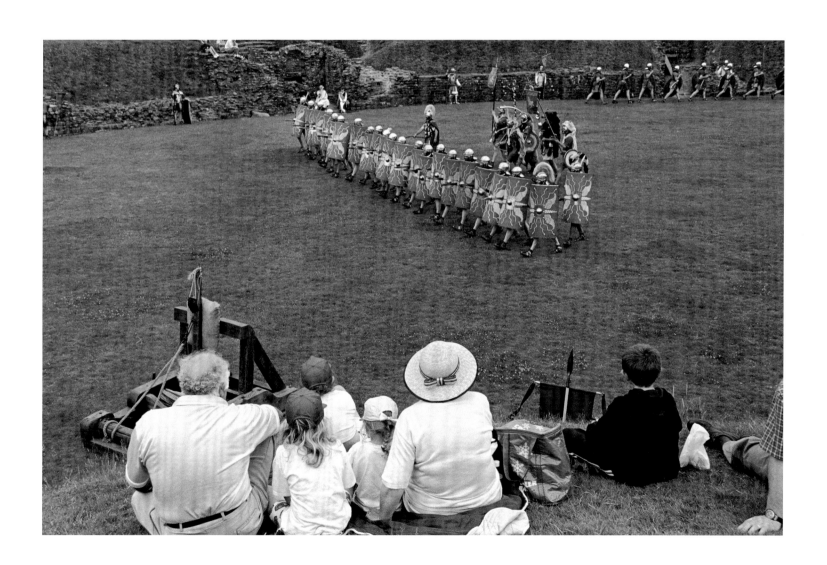

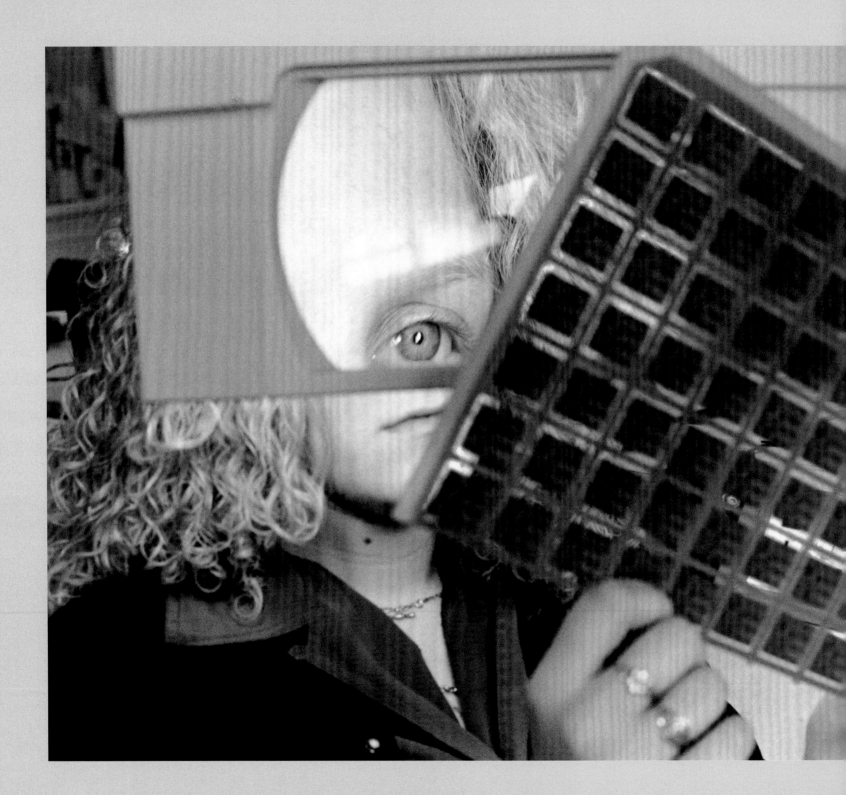

Captions to the Plates

Biography

Exhibitions and Collections

Bibliography

Captions to the Plates

1 The Gorsedd [bardic] Procession.
 Carmarthen, 1974.
2 Easter Chapel Walk. Six Bells, 1975.
3 Promenade. Tenby, 1974.
4 Colliery rest room. Pentwyn, 1993.
5 Casting at the Metal Box factory.
 Neath, 1967.
6 Café. Laugharne, 1974.
7 Pub sing-song. Sennybridge, 1973
8 Old Boys' rugby match.
 Rhondda Valley, 1974.
9 Students' protest gathering.
 Newport, 1973.
10 Artillery range. Mynydd Eppynt, 1973.
11 Glaslyn river estuary. Porthmadog, 1984.
12 Wales v. France international rugby
 match. Cardiff, 1976.
13 Welsh Cross-Country Championships.
 Bridgend, 1979.
14 Sheep washing. Lower Chapel, 1973.
15 Sheepdog trials. Llandderfel, 1983.
16 A day-trip coach party. Aberavon, 1971.
17 Open-air service. Criccieth, 1986.
18 Cardiff v. Everton football match.
 Cardiff, 1977.
19 Judging sheep. Llanafan-fawr, 1983.
20 The Society of the Sacred Cross.
 Lydart, 1973.
21 Miners' holiday fortnight.
 Barry Island, 1973.
22 Flooding. Ely, 1973.
23 Wild pony. Black Mountains, 1974.

24 Tintern Forest. Tintern, 1976.
25 Head of the Valley (A4061).
 Rhondda Valley, 1995.
26 Tug-of-war at the Young Farmers' meeting.
 Brecon, 1973.
27 Children's sports day. Pen-y-lan, 1976.
28 Mould preparation. Shotton, 1974.
29 Summit of the mountain. Snowdon, 1978.
30 Welsh National Opera chorus.
 Cardiff, 1986.
31 Father and baby competition.
 Pwllheli, 1978.
32 A condemned street. Cardiff, 1975.
33 Rugby club Christmas party.
 Taff-Ely, 1978.
34 Town brass band. Llanidloes, 1973.
35 Family get-together. Castleton, 1987.
36 Group photograph. Castleton, 1989.
37 Fish-and-chip shop. Kinmel Bay, 1976.
38 'Belle Vue' stores. Rosebush, 1989.
39 Primitive sculpture. Aber Eiddy, 1974.
40 Baby-care unit at Butlin's Holiday Camp.
 Pen-y-chain, 1986.
41 Horse sales. Llanybyther, 1976.
42 The annual Miss Sunny Rhyl beauty
 contest. Rhyl, 1972.
43 Welsh Leek and Onion Championships.
 Aberavon, 1973.
44 Newport Bowling Club. Newport, 1977.
45 Drug addiction. Brynmill, 1972.
46 Promenade. Barry Island, 1981.
47 Waiting for a bus. Cardiff, 1973.

48 Funfair. Barry Island, 1971.
49 Lewis Merthyr, a mine that is closing
 down. Tre-hafod, 1979.
50 Slag-heap sledge run. Abertillery, 1977.
51 House plants. Porthmadog, 1976.
52 Clothes worn by the family of Lloyd
 George. Criccieth, 1986.
53 Local eisteddfod. Upper Chapel, 1973.
54 Civic parade. Llanidloes, 1973.
55 Junior Ballroom Dancing Championships.
 Bargoed, 1973.
56 Disco. Barry, 1973.
57 Pouring at the steelworks.
 Llanwern, 1977.
58 The Central Wales railway line.
 Cynghordy, 1993.
59 Graffiti. Commins Coch, 1989.
60 'Milking' at the Royal Welsh Show.
 Builth Wells, 1978.
61 Cottage-cured bacon.
 Upper Chapel, 1973.
62 Traditional Welsh costume.
 St David's, 1989.
63 French students. Blaenavon, 1996.
64 Artificial sky at the School of Architecture.
 Cardiff, 1999.
65 Giant vegetable show.
 Llanharry, 1997.
66 Ford engine plant. Bridgend, 1996.
67 'Belle Vue' stores. Rosebush, 1994.
68 Coach stop. Forge Side, 1997.
69 Arts Ball. Newport, 1985.

70 Wet T-shirt competition.
 Pontardawe, 1995.
71 South beach. Tenby, 1995.
72 Sheepdog trials. Nant Peris, 1996.
73 Church land maintenance.
 Llandovery, 1996.
74 Epitaxial Products. St Mellons, 1996.
75 Wedding walk. Brecon, 1996.
76 Promenade. Rhyl, 1997.
77 Main road. Brecon Beacons, 1973.
78 Traffic accident. Glyn Neath, 1998.
79 Café. Llanwrtyd Wells, 1997.
80 Chuck's American Diner.
 Barmouth, 1998.
81 Promenade. Rhyl, 1997.
82 Beach. Porthor, 1997.
83 Boundary fence of refuse transfer site.
 Penparc, 1999.
84 The Sun Centre. Rhyl, 1986.
85 Rain in St Mary's Street. Cardiff, 1982.
86 Ladies' night. Usk, 1994.
87 First-aid course at the Tertiary College.
 Rumney, 1998.
88 Welsh Assembly campaign.
 Newport, 1997.
89 Last night of the Welsh Proms.
 Cardiff, 1995.
90 Easter Chapel Walk. Cwm, 1999.
91 Roman Re-Enactment Society.
 Caerleon, 1997.
92 Circuit board examination.
 Tredegar, 1998.

Biography

1934 David Hurn is born on 21 July in Redhill, Surrey, of Welsh parents. Spends childhood in Wales.

1948–52 Attends Dorchester Grammar School, Dorset.

1953–55 Attends Royal Military Academy, Sandhurst.

1955–57 As a self-taught photographer, works as assistant to Michael Peto and George Vargas at the Reflex Agency, London.

1957–70 Works from London as a freelance photographer for newspapers and magazines, including *The Observer*, *The Sunday Times*, *Look* and *Life*.

1967 Joins Magnum Photos cooperative agency.

1971 Returns to Wales, from where he has worked ever since.

 Editorial adviser to Bill Jay, *Album* photographic magazine London.

 Receives Welsh Arts Council Award.

1972–77 Member of the Photographic Committee, Arts Council of Great Britain.

1973–90 Head of the School of Documentary Photography, Gwent College of Higher Education, Newport, Gwent, Wales.

1975 Awarded Kodak Social Photographic Bursary.

1975–77 Member of the Arts Panel, Arts Council of Great Britain.

1978–87 Member of the Council for National Academic Awards, UK.

1979–80 Distinguished Visiting Artist and Adjunct Professor, Arizona State University, Tempe, USA.

 Awarded UK/USA Bicentennial Fellowship.

1987–88 Receives Imperial War Museum Arts Award.

1993–94 Awarded Bradford Fellowship.

1995 Awarded Arts Council Wales Bursary.

Exhibitions and Collections

Selected Individual Exhibitions

1971 Serpentine Gallery, London, England

1973 Bibliothèque Nationale, Paris, France

1974 National Museum of Wales, Cardiff, Wales
The Photographers' Gallery, London, England

1976 Rencontres Internationales de Photographie, Arles, France
Centre d'Animation Culturelle, Douai, France
École Municipale des Arts Décoratifs, Strasbourg, France

1977 FNAC Étoile Gallery, Paris, France
Arnolfini Gallery, Bristol, England
École des Beaux-Arts, Angers, France
Musée du Château d'Eau, Toulouse, France
Rheinisches Landesmuseum, Bonn, Germany
Rathaus, Augsburg, Germany
Stadtbücherei, Stuttgart, Germany

1978 Städtisches Museum, Bochum, Germany
Northlight Gallery, Arizona State University, Tempe, USA
Gemeentelijke Van Reekum Galerij, Apeldoorn, Netherlands
Culturele Raad, Leeuwarden, Netherlands
Openbare Bibliotheek, Arnhem, Netherlands
Culturele Centrum, Winterswijk, Netherlands
Canon Photo Galerij, Amsterdam, Netherlands
University of Idaho, Moscow, USA
Galeria Spectrum, Barcelona, Spain
Galeria Spectrum, Zaragoza, Spain

1979 San Carlos Opera House, Lisbon, Portugal
University of Idaho Museum, Moscow, USA
University of New Mexico, Albuquerque, USA
Texas Christian University, Fort Worth, USA
Midland Group Gallery, Nottingham, England

1980 Fifth Avenue Gallery, Scotsdale, Arizona, USA
Sterling College of Art, Kansas, USA

1981 Les Rencontres d'Olympus, Paris, France

1982 Contrasts Gallery, London, England
Olympus Gallery, London, England
Malmö Museum, Malmö, Sweden
Palais des Congrès, Lorient, France

1983 Olympus Gallery, Tokyo, Japan
Palais des Beaux-Arts, Charleroi, Belgium

1984 Olympus Gallery, Hamburg, Germany
Ffotogallery, Cardiff, Wales

1985 The Photographers' Gallery, London, England
National Museum of Photography, Bradford, England

1986 Cambridge Darkroom, Cambridge, England
Axiom Gallery, Cheltenham, England
Stills Gallery, Edinburgh, Scotland

1994 Newport Museum, Newport, Wales
National Museum of Photography, Bradford, England

Selected Group Exhibitions

1972 'Personal Views 1850–1970'
Toured UK and Europe, first gallery in
UK being the British Council Gallery in
London; first gallery in Europe being
Deutsche Gesellschaft für Fotografie,
Cologne, Germany
1978 'Images des Hommes'
Toured Europe, first gallery being Studio du
Passage, Brussels, Belgium
1980 'Visitors to Arizona 1846–1980'
Phoenix Museum, Arizona, USA
1983 'British Photography 1955–1965'
The Photographers' Gallery,
London, England
'Images of Sport'
Ffotogallery, Cardiff, Wales
'Autographs'
Cambridge Darkroom, Cambridge, England
1985 'Quelques Anglais'
Centre National de la Photographie,
Paris, France
'The Miner's World'
Touring show, first gallery being Midland
Group, Nottingham, England
'Take One: British Film Stills'
Touring show, first gallery being The
Photographers' Gallery, London, England
1989 'Through the Looking Glass: Photographic
Art in Britain 1945–1989'
Barbican Gallery, London, England
'In Our Time: The World as Seen by
Magnum Photographers'
ICP, New York, Paris, London, etc.

1991 'Distinguished Visiting Artists'
(with William Wegman) Northlight Gallery,
Arizona State University, USA
1994 'Revelations. Male and Female Nudes'
John Jones Gallery, London, England
'A Positive View'
The Saatchi Gallery, London, England

Selected Public Collections

National Museum & Gallery Cardiff, Wales
Welsh Arts Council, Cardiff, Wales
Contemporary Arts Society for Wales, Cardiff, Wales
National Library of Wales, Aberystwyth, Wales
Arts Council of Great Britain, London, England
British Council, London, England
Bibliothèque Nationale, Paris, France
FNAC, Paris, France
Musée du Château d'Eau, Toulouse, France
International Center of Photography, New York, USA
Center for Creative Photography, University of Arizona,
 Tucson, USA
University of New Mexico, Albuquerque, USA
San Francisco Museum of Modern Art, California, USA
California Museum of Photography, University of
 California at Riverside, USA
International Museum of Photography, George Eastman
 House, Rochester, New York, USA

Bibliography

Books by David Hurn

David Hurn: Photographs 1956–1976. With an introduction by Sir Tom Hopkinson.
Arts Council of Great Britain, London, 1979.

On Being a Photographer (with Bill Jay). LensWork Publishing, Portland, Oregon, 1997.

On Looking at Pictures (with Bill Jay). LensWork Publishing, Portland, Oregon, forthcoming.

Selected Books with Photographs by David Hurn

A Day in the Life of London. Jonathan Cape, London, 1984.
One Moment of the World. Katsuji Date, Tokyo, 1984.
Ireland: A Week in the Life of a Nation. Century Publishing, London, 1986.
History of Photography. Hamlyn, London, 1987.
Bons Baisers. Cahier d'Images, Paris, 1987.
In Our Time. André Deutsch, London, 1989.
Music. André Deutsch, London, 1990.
À l'Est de Magnum, Arthaud, Paris, 1991.
The Circle of Life. Harper, San Francisco, 1991.
L'Argot d'Éros. Marval, Paris, 1992.
Il Medico e il reportage. Peliti Associati, Rome, 1992.
Magnum Cinema. Cahiers du Cinéma, Paris, 1994.
Contemporary Photographers. St James Press, Detroit, 1995.
Magnum Landscape. Plume, Paris, and Phaidon, London, 1996.
The Photo Book. Phaidon, London, 1997.
Magnum Photos (Photo Poche). Nathan, Paris, 1997.
1968: Magnum Throughout the World. Hazan, Paris, 1998.
Young Meteors. Jonathan Cape, London, 1998.
Hugs and Kisses. Abbeville Press, New York, London and Paris, 1998.